*An Early View
of the Shakers*

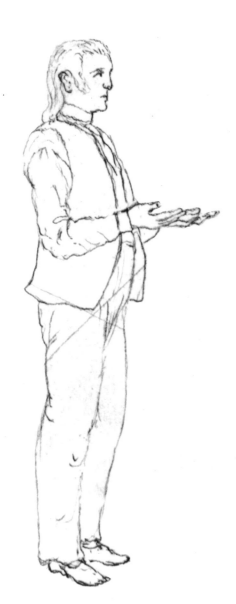

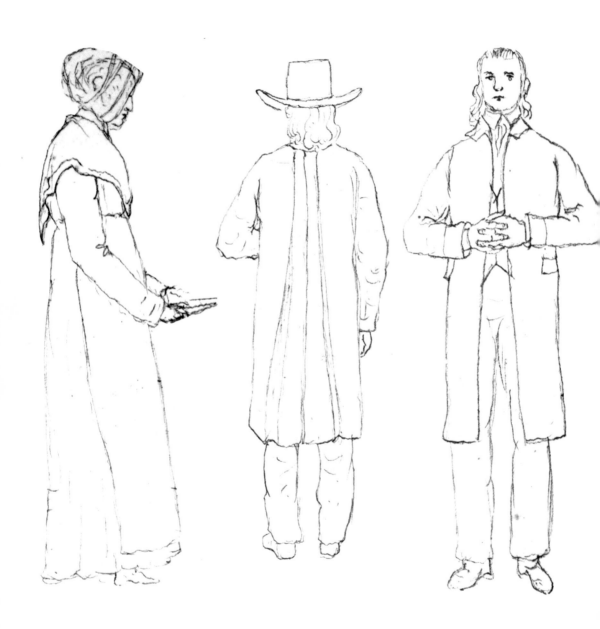

An Early View of the Shakers

Benson John Lossing and the
Harper's Article of July 1857

*With Reproductions of
the Original Sketches
and Watercolors*

Edited by Don Gifford

Foreword by June Sprigg

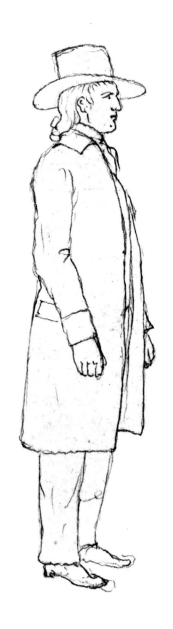

Published for
Hancock Shaker Village, Inc.
by
University Press of New England
Hanover and London

University Press of New England

Brandeis University

Brown University

Clark University

University of Connecticut

Dartmouth College

University of New Hampshire

University of Rhode Island

Tufts University

University of Vermont

Printed in Japan

Library of Congress Cataloging-in-Publication Data

An early view of the Shakers.

 "Text of 'The Shakers' by Benson John Lossing": p.
 1. Shakers—New York (State)—New Lebanon—History.
2. New Lebanon (N.Y.)—Description. I. Gifford, Don.
II. Lossing, Benson John, 1813-1891. Shakers. 1989.
III. Hancock Shaker Village.
BX9768.N5E2 1989 289'.8'0974739 88-40348
ISBN 0-87451-463-0 (pbk.)
ISBN 0-87451-472-X

5 4 3 2 1

Contents

Foreword

There is a certain kind of late summer day here in the Berkshire hills, where Massachusetts meets New York. Clarity is the word that seems to suit what I have come to call "the golden days." Once the morning mist burns off, there is nothing of haze, nothing vague in what meets the eye. The sky is clear blue. Strong golden light illuminates precisely each leaf and clapboard and shingle. Each blade of grass casts its own crisp sliver of shadow.

There is, however, a peculiar quality in the light, in that it transforms what it makes clear. It is kind to what it elucidates, lending grace with benign indiscrimination. Shabby houses look more comfortable, more like good places to grow up in. The land appears lush and fruitful, even where only milkweed and goldenrod grow.

Such is the light of summer past its prime. It is as if the light tries to make up for what the earth can't help betraying. Here and there fingers of red poke holes in the green of summer. The sky is still bright well into the evening, but nights are wool-blanket cold. These are the bittersweet days. They bring the last of the bounty, and the killing frost.

It was on just such a day in August more that one hundred thirty years ago that Benson J. Lossing rode into New Lebanon, New York, to visit the Shakers there. His purpose was to write and illustrate an article on the oldest Shaker community, the hub of eighteen Shaker settlements from Maine to Kentucky.[1] Having made some errors of fact in a brief earlier piece on the Shakers, or United Society of Believers, Lossing was anxious to please. The desire, I think, was mutual. During sixty-nine years of existence, the New Lebanon Shakers had suffered much bad press. A few years earlier, Charles Dickens had made them figures of ridicule in his *American Notes*. The society was naturally eager to receive an observer whose sincerity and manner promised a sympathetic report.

There was another, more compelling reason for the Shakers' cooperation, however. By 1856, changes in the nature of membership had become of serious

1. Although Shaker founder Ann Lee settled in Watervliet, New York, in 1776 with her English followers, the first community formally established as a communal living group was at New Lebanon, where Shakers "gathered into order" in late 1787.

concern to the society. It was not that the numbers were declining; it was that more people came to the Shakers for reasons other than the desire for true spiritual growth. The society was in danger of becoming a haven for what the Believers called "bread and butter" Shakers, who were content to take what was offered and not give their souls in return. More and more children raised by the society chose to leave when they came of age. Fewer adults were willing to convert. To outsiders like Lossing, the problem was not evident. He saw 500 Believers in eight large communal Families. The village appeared to thrive. To the Shakers, a favorable article in a widely read periodical must have seemed like publicity of the best sort.

In those two evenings and two days of August 1856, Lossing attended private and public worship services, visited workshops, met several Shakers, and observed some of their successful industries. He spent most of the first two days with Elder Frederick Evans, one of two Elders at the North Family, the novitiate or "gathering" order.

It was not coincidence that Lossing spent so much time with Evans. As a leader of the order to which new converts came, Evans had perhaps the most important role in the community at that time. At forty-eight, a few years Lossing's senior, Evans was entering the prime of his career. Himself a convert at age twenty-two, Evans burned with the conviction that the celibate Shakers could continue to add to their ranks through genuine spiritual conversion. To this end he spent his life turning outward to the world—preaching in the meetinghouse, travelling as far as his native England on proselytizing tours, and writing and publishing extensively.

Lossing also spent much of his visit in the company of Brother Isaac Newton Youngs, who led him on his tour through the village. Intelligent, articulate, and possessed of many abilities, Youngs was a highly regarded Believer. Brought by his family into the Shakers when he was a baby, Youngs had spent all but the first six months of his life with the Shakers. At sixty-three, his life very nearly spanned the entire history of the New Lebanon community.

Few other Shakers knew the life of the village as well as Youngs. His skill with words and his powers of observation earned him the responsibility of recording the events of daily life in the Church Family Record. He was a prolific writer, and, like Lossing, devoted to the preservation of knowledge. Isaac Youngs's historical account of his community and his other writings have proved of immense value to scholars. It is not an overstatement to say that if no other Shaker records survived, Youngs's work would by itself present a comprehensive picture of Shaker life.

Benson Lossing wrote extensively about Frederick Evans in his article, clearly taken with the Elder's energy and vision. What is hard to understand is that Lossing did not mention Isaac Youngs at all. We know that Youngs was his host only because of an entry in the journal Youngs kept. It is curious to those familiar with Shaker history why Lossing ignored his meeting with this remarkable Shaker.

The answer, I think, lies in Youngs's private journal for that year. At sixty-three, he was tired and suffering from increasingly poor health. His primary job was writing the Church Record. The brief entries in his own private journal reflect his frustration with his work. He was distracted by too many unimportant jobs—fixing clocks, repairing sewing machines, sharpening scissors, tailoring, making lamp shades. On the first day of 1856, he complained, "I have nothing special to say—it is the same old round of drive drive at work—I have so many ways to go—and am so unsteady about my work that it seems to me that I bring to pass but little."[2]

His tone was sometimes querulous. He grumbled about his Shaker Family, especially the younger members. They wanted too many clocks. They were getting too self-centered and materialistic. They didn't paint the windows properly. He fretted about his health. His stomach bothered him. He was troubled by an ailment in his neck. "O I feel sorrowful Reflections," he wrote in August 1856. "My health is not very good—I feel drawing to a close . . ."

Hardest of all, Youngs was forced to contemplate not only his own mortality, but that of his beloved Shaker village. Like Frederick Evans and Benson Lossing, Youngs yearned to see the Believers thrive. Unlike Evans and Lossing, however, he could not persuade himself that there was any reason to hope. He perceived clearly what Evans did not want to believe and what Lossing was not able to see—that the Shaker society in New Lebanon, as elsewhere, was in the bittersweet August of its life.

That what had been so good and full of vitality should begin to dwindle and fade was unbearably sad to him. The children and youth were leaving, the hired men who were increasingly necessary to maintain the farms were a bad influence, and the reaction of the world on whom the Shakers depended for converts was "universal indifference," in spite of the efforts of Shakers like Frederick Evans.

2. Courtesy Western Reserve Historical Society, Cleveland, Ohio, Shaker manuscript collection VB-134, microfilm reel 35.

Profoundly distressed, Youngs poured his feelings into three pages of his journal on the last day of August, less than two weeks after Lossing's visit:

> There has been considerable exertion of late for two or three years to go out on a mission, to preach, hold meetings, & to lecture on our faith & principles, & generally the world have given great attention, glad to hear, are surprised that they have not known more of the truth about Shakers—some gather near & feel much love—&c—but after all, scarce get any conviction, or real faith, they don't want the *cross!* with all our labor & expense scarce any are induced to come in, of *Adults*. We have gathered in a good many children the year past—but as before observed, there is no reliance to be placed on them—and what we are going to do—The Lord only knows.

Did Youngs give Lossing a sense of his despair? I think not. It would have served no useful purpose, and I doubt that this Believer would have confided his depression and doubts to a worldly stranger on a three-day visit. My hunch is that Youngs simply led Lossing around, a quiet and unremarkable host. What impression Lossing formed of Youngs, good or bad, we will never know.

Lossing returned home with his notes and pencil sketches. His article appeared in *Harper's* in July the next year. It was what the Shakers expected, an accurate, respectful, even admiring account of their community.

But Isaac Youngs was right. There was no influx of new Believers. New Lebanon's eight communal Families closed one by one as the nineteenth century passed and the twentieth century progressed.

Today, the Shaker settlement at New Lebanon is no more. Some of the buildings that Lossing visited remain in use by the Darrow School, a private institution that purchased the property more than fifty years ago. The rest have long since vanished. Fields, pasture, and orchards have given way to the tangle of second-growth forest.

Never mind. In the pages of the July 1857 issue of *Harper's,* three days at New Lebanon live on, preserved forever in late-summer light, warm and golden as amber. We can be grateful to Benson Lossing for that, and to Don Gifford for his informative essay and notes on the text and illustrations.

Pittsfield, Massachusetts
September 1988

June Sprigg
Curator of Collections
Hancock Shaker Village

Preface and Acknowledgments

This volume would not have come into existence had it not been for discoveries made by the late Mary L. Richmond of Williamstown, Massachusetts, in the course of preparing her comprehensive Shaker bibliography. Mrs. Richmond was convinced that the Benson J. Lossing watercolors and pencil sketches, together with his illustrated article, "The Shakers" in *Harper's New Monthly Magazine* (July, 1857) would make an interesting publication. She urged me to undertake the project, and her vast fund of knowledge and patience encouraged and sustained me throughout. She put me in touch with George J. Finney who made available to me his unpublished article, "A Visit to the Shakers: Lossing not Whitman." The article and Mr. Finney's conversation were a great help in resolving possible confusions about the authorship of Lossing's text (see pp. 69ff., "A Note on the Text: Some Confusions Resolved.").

I want to thank Mrs. Lawrence K. Miller, President of Hancock Shaker Village, Inc., for support of this project and Robert F. W. Meader, Librarian at Hancock Shaker Village for his advice and help in the final stages of preparation of this project. As always I am indebted to the research staff of the Sawyer Library at Williams College, to Lee Dalzell, David Shea, and to Sarah McFarland who doubles as Research Librarian and Curator of the Shaker Collection.

The completeness of the available Lossing materials is surprising, even unnerving. In addition to the illustrated article itself, there are seven pencil sketches and nineteen watercolors, eighteen of which were used to guide the wood-engravers who prepared the wood-blocks at the Lossing-Barritt workshop. The notebook Lossing kept on the occasion of his visit to New Lebanon in August 1856 and a January 1857 draft of Lossing's article are in the Berg Collection at the New York Public Library, and the final draft of the article is at the Huntington Library in San Marino, California. What, I wonder, did that man ever throw away?

Illus. 1a, 1b, 1c, and 1d, 2, 3, 4, 5a, 6, 7a, 8a, 8b, 10a and 10b, 11, 12, 13, 14a and 14b, 15, 16, and 18 are reproduced, Courtesy, the Henry E. Huntington Library and Art Gallery, LS 14, Lossing, Benson John, "The Shakers."

Illus. 5b, Courtesy, The Henry Francis du Pont Winterthur Museum, The Edward Deming Andrews Memorial Shaker Collection, No. SA 1438.

Illus. 9 and 17, Courtesy, Hancock Shaker Village, Inc., gift of George J. Finney.

Williamstown, Massachusetts Don Gifford
25 February 1988

An Early View
of the Shakers

Notes on the Illustrations

The wood-engravings for Lossing's article were prepared from his water-colors in the Lossing-Barritt workshop in New York City. Eleven of the engravings bear the Lossing-Barritt imprint, but that does not necessarily mean that the other eight were jobbed out to other wood-engraving firms. All of the buildings and scenes in Lossing's sketches were made in the Church and Center Families at New Lebanon except illus. 2 which is a view from the south of the North or Gathering Family, a short walk away.

Twelve of the original wood-blocks (illus. 1, 2, 3, 4, 5, 6, 7, 9, 12, 16, 17, and 18 as listed below) were reused by Charles Nordhoff to illustrate his account of the Shakers in *The Communistic Societies of the United States* (Harper's, New York, 1875). Nordhoff had been an editor at Harper's when Lossing's article was published there in 1857.

1a. Shaker Costume. Watercolor (5″ x 8″), undated. Lossing combined several drawings (including 1b, 1c, and 1d) to produce this watercolor.

1b. Sabbath Dress, front view. Pencil sketch (4¼″ x 1¾″), undated. Sabbath Dress, back view. Pencil sketch (5″ x 2″), undated.

1c. Common Working Dress. Pencil sketch (4¼″ x 1½″), undated.

1d. Shaker Costumes. Pencil sketch (4¼″ x 4⅔″), undated.

2. Northern Portion of the Shaker Village. Watercolor (5¾″ x 9″), undated. This is a view, taken from the south, of the North or Gathering Family at New Lebanon.

3. The Office and Store. Watercolor (4¾″ x 7″), dated 18 August 1856. The Office was the residence of the Trustees, the Shaker officials who handled the community's financial, commercial and legal dealings with the World's People.

4. The Meeting House. Watercolor (4½″ x 8½″), dated 18 August 1856. The annex at the left was the residence of the Ministry.

5a. Interior of the Meeting House. Pencil sketch (8½″ x 12¼″), undated. The benches at the left comprised "the Lobby" and were reserved for the World's People when they attended open Sunday services. The louvered windows in the far wall were for the use of the Ministry who did not attend services when outsiders were present but supervised from above. In winter, several cast-iron stoves, their stovepipes suspended beneath the ceiling, heated the room. The solitary seated figure would not have been "praying" in the usual sense of the term because the Shakers did not believe in verbal prayer but in a form of wordless meditation called "spiritual aspiration." The sketch, with its notations for colors, etc., was clearly made on the spot as a preliminary to subsequent production of the watercolor.

5b. Interior of the Meeting House. Watercolor (6″ x 2½″), dated 18 August 1856.

5c. Interior of the Meeting House. Wood-engraving (4¼″ x 2″).

6. The Dance. Watercolor (4½″ x 6½″), dated 16 August 1856 (Saturday). The Dance depicts the "Exercises" during the Saturday evening worship service in the Church Family's dwelling which Lossing describes on pp. 33–34, not the public Sunday worship service which he describes on pp. 35–40.

7a. Sisters in Everyday Costume. Watercolor (2″ x 4″), dated 18 August 1856. Lossing has written on the watercolor in pencil, "Let these two face each other," as they do in the wood-engraving.

7b. Sisters in Everyday Costume. Wood-engraving (4½″ x 3½″).

8a. The Hydraulic Press. Watercolor (4¼″ x 4½″), undated. The press was in the Center Family's Herb House.

8b. Hand Press. Watercolor (3¼″ x 3″), undated. No wood-engraving of this watercolor was included as an illustration in Lossing's article. The hand press was in the Herb House; see "small presses," p. 49.

9. The Herb House. Watercolor (3½″ x 8½″), undated.

10a. The Laboratory. Pencil sketch (6¼″ x 9″), undated. This sketch of the interior of the Laboratory or Extract Building in the Center Family (constructed in 1850) includes notations that detail the mechanical functions of the equipment and identify the figure as that of Brother James Long, a chemist and the manager of the Extract Department; see Lossing article n59.

10b. Interior of the Laboratory. Watercolor (4″ x 5½″), dated 18 August 1856.

10c. The Laboratory. Wood-engraving (4½″ x 3″).

11. Extract House. Or Laboratory in the Center Family. Watercolor (6¾″ x 8¾″), undated.

12. Vacuum Pan and Powdering Mill. Watercolor (4″ x 2½″), undated. This water-color was the guide for two wood-engravings, that of the vacuum pan (p. 174 in original *Harper's* article) and that of the powdering mill (p. 175 in original *Harper's* article). The pan was in the Extract House or Laboratory. The pencil notations on the watercolor detail the mechanical parts of the pan.

13. Crushing Mill. Watercolor (5½″ x 4½″), undated. The sketch is labelled "Mill for crushing green herbs," though the text of Lossing's article, p. 50, suggests that the mill was used to pulverize roots.

14a. Finishing Room. Pencil sketch (6½″ x 10½″), undated. The title reads "Finish-ing Room where the extracts are labelled." Lossing has made some notes about colors and textures in the room, and a legend identifies the background figure on the right as Sister Jane Rea (1819–63) who entered the Second Family at New Lebanon in 1828. The foreground figure on the right is identified as Sister Eliza Avery (1814–86) who entered the Second Family in 1819. The figure on the left is unidentified.

14b. Finishing Shop (Labelling). Watercolor (4¼″ x 6¼″), dated 18 August 1856.

14c. Finishing Room. Wood-engraving (3¼″ x 4¼″).

15. Powdering Mill. Pencil Sketch (4½″ x 3½″), undated. This sketch was the basis for the watercolor of the powdering mill (see illus. 12). The notations on the sketch detail the functioning of the mill.

16. The Seed House (Ancient Church). Watercolor (5¼″ x 7½″), dated 18 August 1856. The building (1785–86) in the Church Family was moved and converted into the Seed House in 1824.

17. The Tannery. Watercolor (4″ x 7½″), undated. The Tannery was in the Church Family. The watercolor is on the verso of the watercolor of the Herb House (illus. 9) and is relatively less finished than the others. The cryptic "column" in pencil in-

structs the wood-engraver to reduce the block to column width, in this case $2\frac{1}{4}''$ x $2\frac{1}{2}''$.

18. The Physician at His Desk. Watercolor (5" x 4"), undated. This watercolor is a portrait of Dr. Barnabas Hinckley; see Lossing article n64.

19. A Shaker School. Wood-engraving ($3\frac{3}{4}''$ x 3"). This wood-engraving of the "school for girls" (Lossing, p. 52) appears facing p. 214 in Charles Nordhoff, *The Communistic Societies of the United States.* Nordhoff reused 12 of the Lossing woodblocks in his book (omitting only the several that depict machinery and the exterior and interior of the Laboratory or Extract House). This illustration of the interior of a Shaker schoolroom depicts a girls' class in session and is reminiscent of Lossing's style. It is interesting that in the January 1857 draft of his article (now in the New York Public Library) Lossing placed much more emphasis on the girls' school than he did in the finished article (see p. 52). There is little evidence, other than a coincidence of impressions, to indicate that the school-room was Lossing's work, but the coincidence is tantalizing.

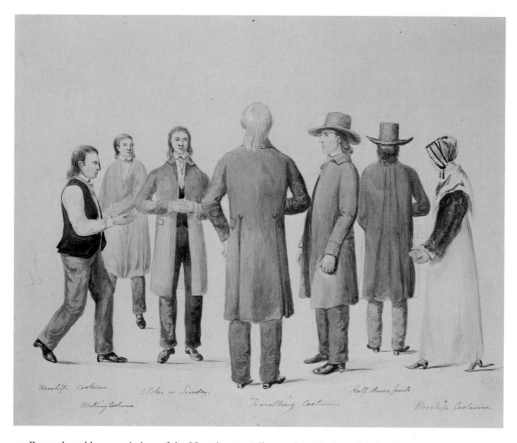

1a. Reproduced by permission of the Huntington Library, San Marino, California.

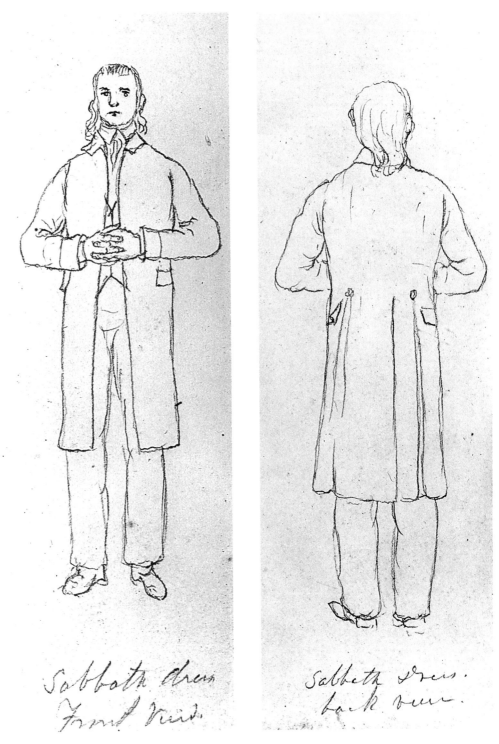

Sabbath dress. Front View. *Sabbath dress. back view.*

1b. Reproduced by permission of the Huntington Library, San Marino, California.

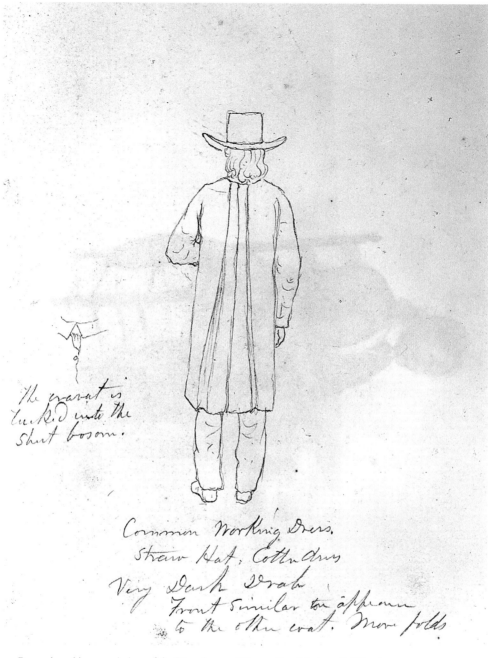

The cravat is tucked into the shirt bosom.

Common Working Dress.
Straw Hat, Cotton dress
Very Dark Drab.
Front similar to appearance
to the other coat. More folds

1c. Reproduced by permission of the Huntington Library, San Marino, California.

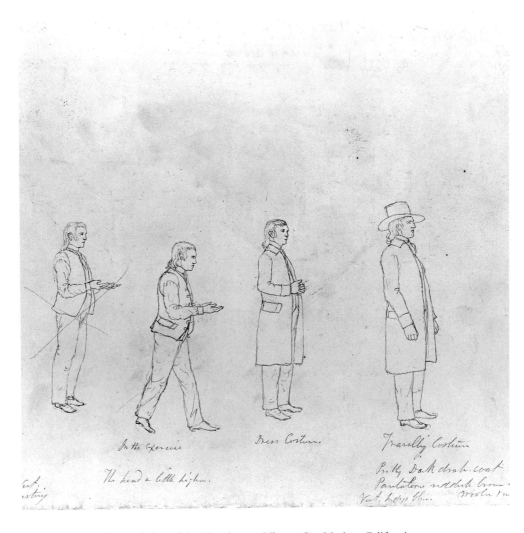

In the Exercise.

The head a little higher.

Dress Costume.

Travelling Costume

Pretty Dark drab. coat
Pantaloons reddish brown.
Vest light blue. woolen tri

1d. Reproduced by permission of the Huntington Library, San Marino, California.

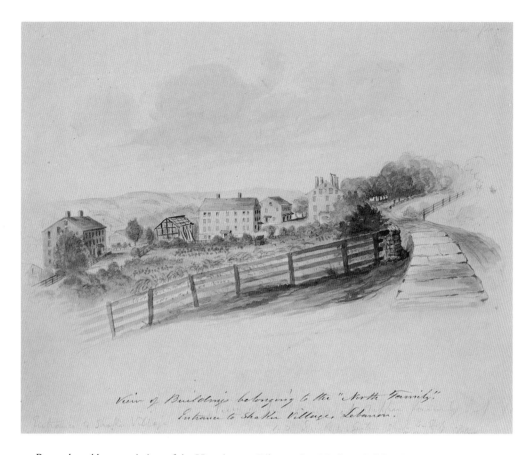

View of Buildings belonging to the "North Family". Entrance to Shaker Village, Lebanon.

2. Reproduced by permission of the Huntington Library, San Marino, California.

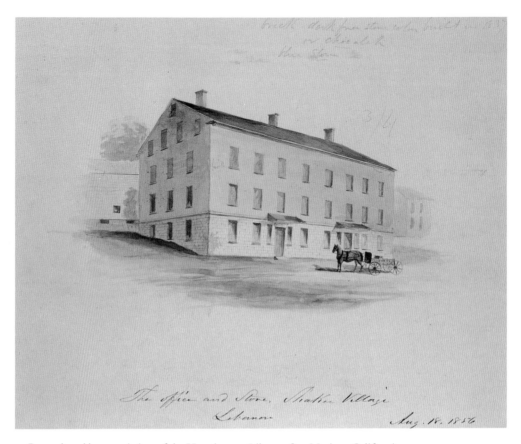

3. Reproduced by permission of the Huntington Library, San Marino, California.

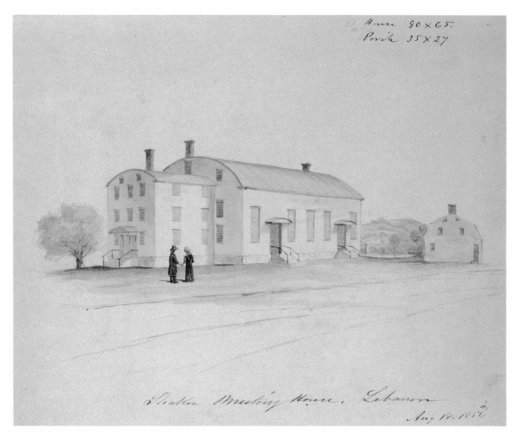

4. Reproduced by permission of the Huntington Library, San Marino, California.

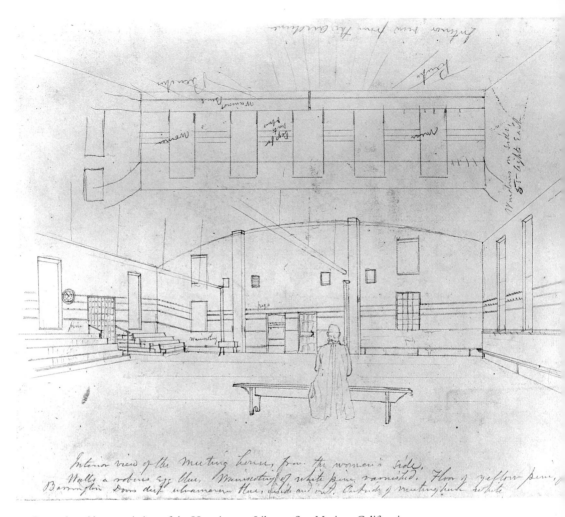

5a. Reproduced by permission of the Huntington Library, San Marino, California.

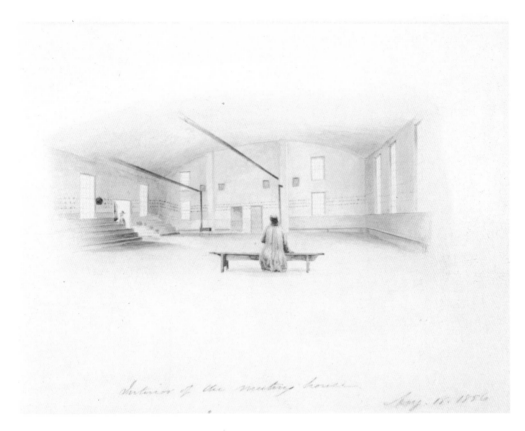

Interior of the meeting house *Aug. 15. 1856*

5b. Courtesy, Henry Francis duPont Winterthur Museum, The Edward Deming Andrews Memorial Shaker Collection, No. SA1438.

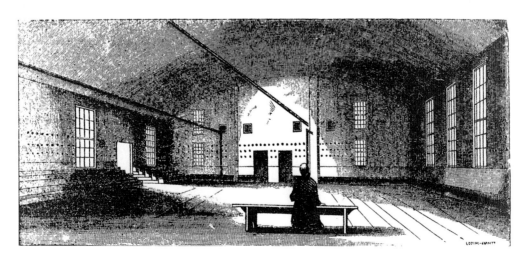

5c.

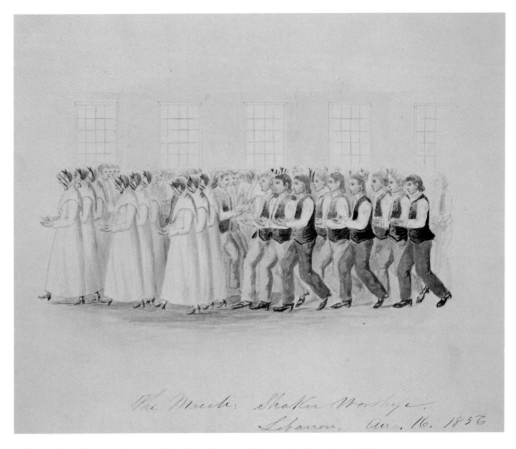

The March. Shaker Worship.
Lebanon, Aug. 16. 1856

6. Reproduced by permission of the Huntington Library, San Marino, California.

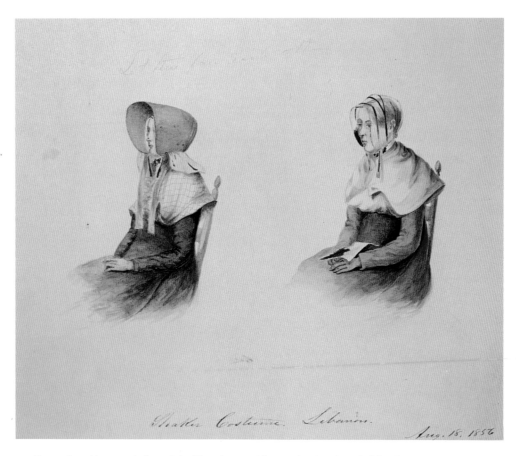

7a. Reproduced by permission of the Huntington Library, San Marino, California.

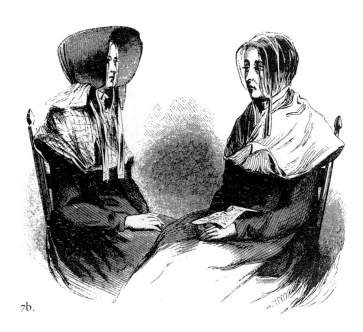

7b.

15

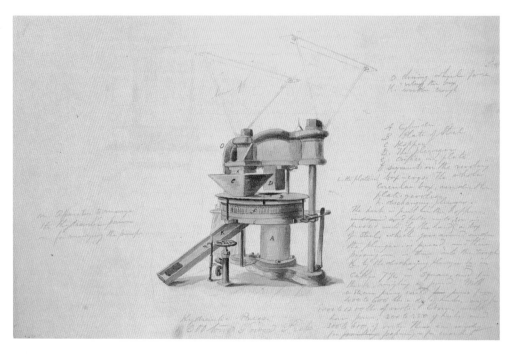

8a. Reproduced by permission of the Huntington Library, San Marino, California.

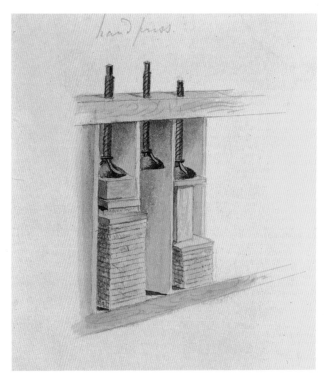

8b. Reproduced by permission of the Huntington Library, San Marino, California.

9.

A Press, in which the liquor is pressed from the crude matter taken from the boiler

B cask, in which the liquor is pressed from the crude matter taken from the boiler

C. Boiler, or steam chest, in which the herbs are cooked in hot steam, 40 lbs to inch pressure.

D. D. Kettles (copper, jacketed with iron,) for boiling the liquor from the press. Ma this

a safety valve

b. pipe for letting in pure spring water. Taken from a spring in slate, 3/4 of a mile distant, in the mountain. Brought in i pipes. Advantage over Every other laboratory

E/ James Long. Manager of the Entire Extract Department.

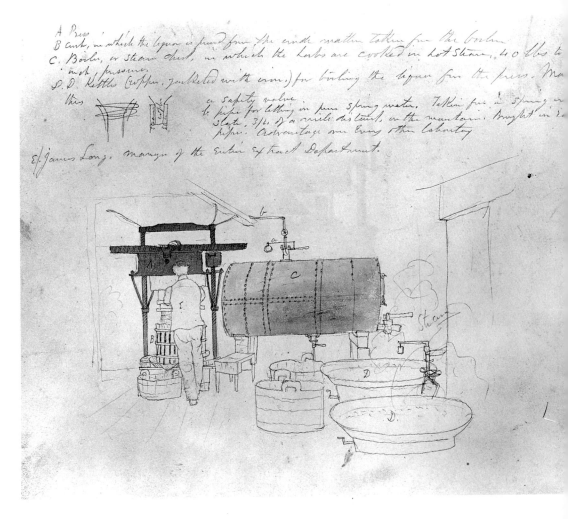

10a. Reproduced by permission of the Huntington Library, San Marino, California.

18

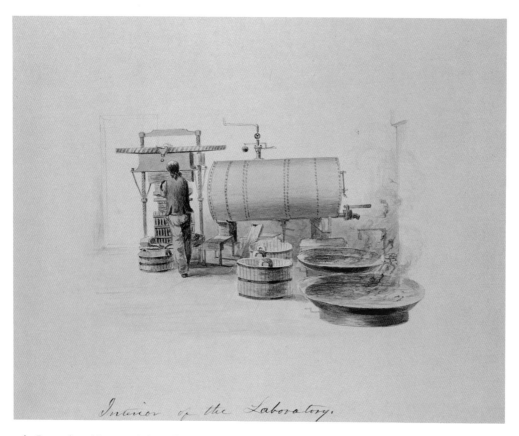

Interior of the Laboratory.

10b. Reproduced by permission of the Huntington Library, San Marino, California.

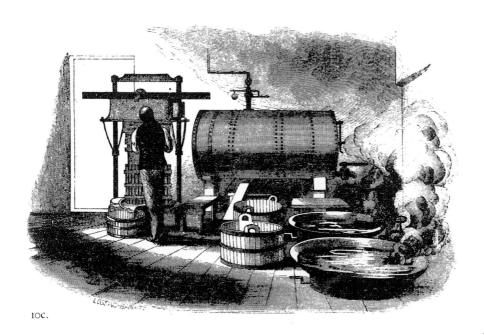

10c.

19

The Laboratory — Lebanon. Built in 1850.
Frame — 36 × 100.

11. Reproduced by permission of the Huntington Library, San Marino, California.

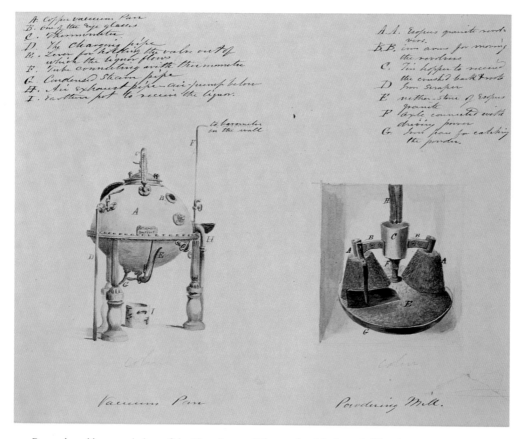

A. Copper vacuum Pan
B. One of the eye glasses
C. Thermometer
D. The charging pipe
E. Lever for holding the valve out of which the liquor flows
F. Tube connecting with the thermometer
G. Condensed Steam pipe
H. Air exhaust pipe — air pump below
I. Earthern pot to receive the liquor.

A.A. Esopus granite rollers.
B.B. Iron arms for moving the rollers
C. Tin hopper to receive the crush'd bark & roots
D. Iron Scraper
E. Nether stone of Esopus granite
F. Axle connected with driving power
G. Iron pan for catching the powder.

to barometer on the wall

Vacuum Pan

Powdering Mill.

12. Reproduced by permission of the Huntington Library, San Marino, California.

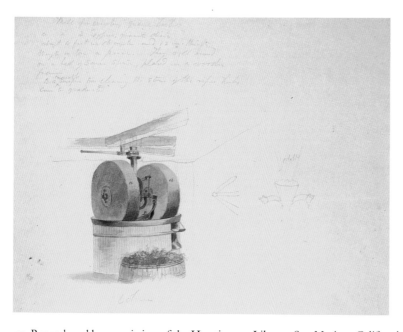

13. Reproduced by permission of the Huntington Library, San Marino, California.

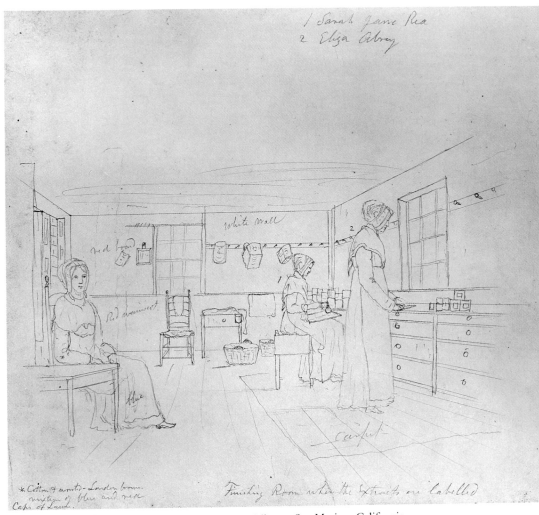

14a. Reproduced by permission of the Huntington Library, San Marino, California.

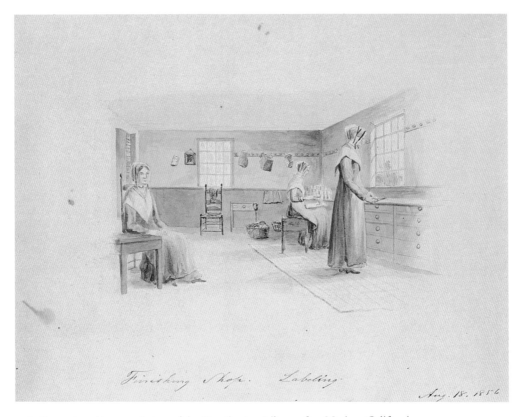

14b. Reproduced by permission of the Huntington Library, San Marino, California.

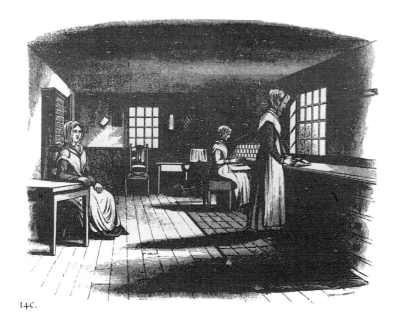

14c.

The barks & roots are
Kiln dried, and then in a
Coarse mill, cracked to about
the consistency of Samp or homing
then ground to an impalpable powder.

All dr...
of B...

Seve
woo...

or dusting mill
Powdering mill.
a. a. Esopus granite, 100 lbs each
move on their own axes.
b an iron Scraper for cleaning the
nether Stone.
C. tin hopper.
d Cloth tube for feeding
the hopper with barks
or herbs, & roots
& nether Stone

15. Reproduced by permission of the Huntington Library, San Marino, California.

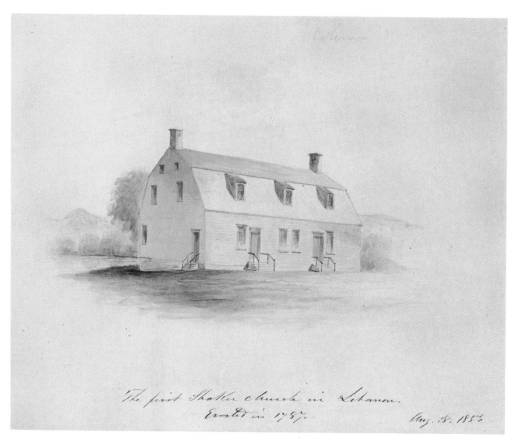

The first Shaker church in Lebanon.
Erated in 1787. Aug. 18. 1856.

16. Reproduced by permission of the Huntington Library, San Marino, California.

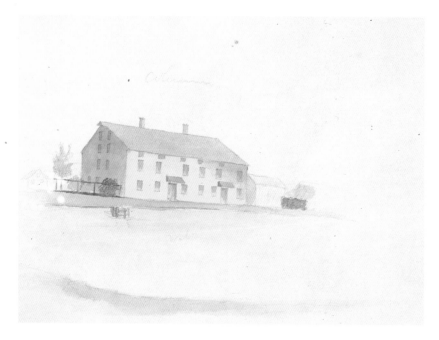

17.

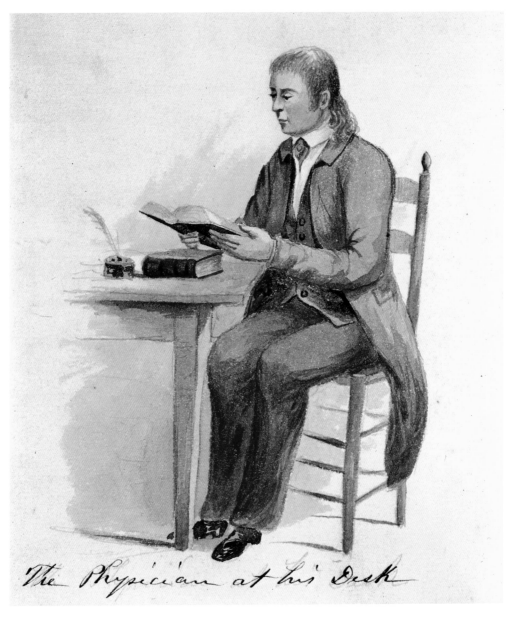

The Physician at his Desk

18. Reproduced by permission of the Huntington Library, San Marino, California.

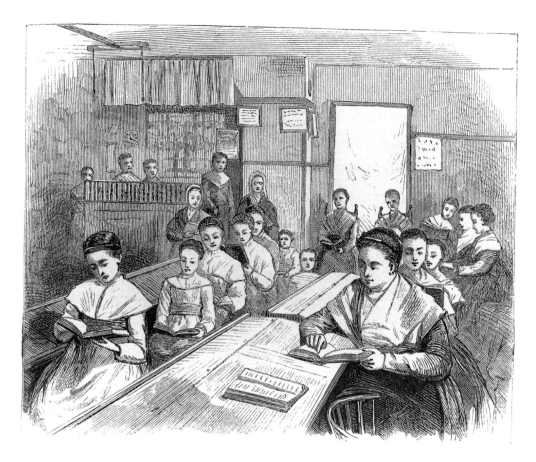

19.

The Shakers

Benson John Lossing

I was at the Canaan railway station in Columbia County, New York, at the middle of a cool and brilliant day in August.[1] I had come from no matter where,[2] and my destination was the beautiful Lebanon Valley, from whose northern margin healing fountains gush out, and attract the sick and the fashionable in the pleasant summer-time. The stage-coach departed on its journey of seven miles from Canaan to Lebanon at half past one o'clock, with nine passengers inside, and three, besides myself, upon the driver's box and the seat upon the roof. Seldom have I enjoyed a journey more. The air was pure and invigorating; the firmament was full of detached masses of magnificent clouds; the foliage of shrub and tree was as rich as in wealthy June, and over hill, and valley, [illus. 1] and intervals, broad shadows, like phantoms, were chasing each other in the noonday splendors that filled earth and air.

Benson John Lossing, "The Shakers" as published in *Harper's New Monthly Magazine,* Volume XV (July, 1857) pages 164–77. The original location of Lossing's wood-engravings as they appeared in the 1857 article is indicated in the text by the illustration number within brackets.

1. Isaac Newton Youngs (1793–1865), a member of the Church Family at New Lebanon, notes in his manuscript journal (now at the Western Reserve Historical Society) that he and Brother Daniel Sering, a guest from the Shaker community at Union village, Ohio, spent the day with Lossing in August 1856. Lossing's watercolors are all dated 18 August 1856 (Monday) with the exception of "The Dance" (illus. 6) which is dated 16 August 1856 (Saturday). These dates indicate that Lossing arrived on Saturday and spent Sunday and Monday as a guest at the New Lebanon community.

2. In his notebook Lossing remarked that he "left Pokeepsie [where he was living in 1856–57] at 8:40 A.M." and travelled to Hudson, New York, via the Hudson River Railroad and to Chatham, Canaan, and Lebanon Springs via the Hudson and Berkshire Railroad and Stage. The Hudson River Railroad advertised (1852 ff.) excursion rates from New York City, "For the accomodation of Passengers wishing to visit this favorite Watering Place [Lebanon Springs, New York] and the Shakers." Lebanon Springs was a flourishing spa and summer resort in the nineteenth and early twentieth centuries, and the nearby Shaker community provided a popular tourist attraction.

The road was smooth but extremely sinuous, for it passed through a hilly country, over the whole surface of which the hand of industry had laid its impressions of cultivation. Down in the valleys the eye rested upon variegated fields, lying there like rich carpets; and up the slopes, to the very summits of the hills, depending from tufts of forest, was tapestry more gorgeous than ever came from the looms of Gobelin. Orchards, grain-fields, meadows, pastures, farm-houses, churches, little villages—these dotted the country in every direction, and each turn in the road brought a new surprise. Beauties came, one after another, like the pictures of a moving panorama; and when, within three miles of Lebanon Springs, a sudden turn gave us a full view of the lovely valley through which their waters flow and two quiet villages[3] lie nestled, a cloud of regret shadowed the sunny feeling which the scene had inspired, for a longer enjoyment of such exquisite pleasure was coveted.

In a few moments new emotions were excited, for on the right, stretching along upon a noble mountain terrace, half way between the deep green valley and the bending sky, lay the Shaker village,[4] surrounded by slopes enriched by the most perfect culture. A portion of it was half hidden by trees and a vail of blue smoke, while the polished metal roof of the house of worship sparkled in the rays of the sun like a cluster of stars.

We arrived at Lebanon Springs at about three o'clock. They gush out from the rocks of a rugged hillside, at the rate of fourteen barrels a minute, and around them is now seated a thriving little village, the offspring of the popularity of the waters. Their taste is like that of rain-water—soft and sweet—and the temperature at all seasons is seventy-three degrees. Gas is continually escaping with a crackling sound, and the water is perfectly limpid. Over the main fountain stoops a magnificent sycamore, full ten feet in circumference at its base, which was planted there by the original proprietor of the spring, after it had been used by him as a riding-whip for a whole day.

But it was not Lebanon Springs, nor the crowd gathered there, nor the

3. The stage approached the two villages from Canaan, New York, five miles to the south and would have passed through New Lebanon (twenty-four miles southeast of Albany, New York) en route to Lebanon Springs, a mile and a half to the north.

4. The Shaker community at New Lebanon consisted of eight "families." The "village" Lossing visited was on the hillside just east of and above New Lebanon. It consisted of the adjoining Church and Center Families, and, a short walk to the north, the North or Gathering Family. The extant buildings of the Church and Center Families have been incorporated into the Darrow School, New Lebanon, New York.

good fare and round of amusements enjoyed by the guests at the hotels, that had invited me to that beautiful valley and its noble surroundings. I had come to visit the people in that quiet Shaker village upon the mountain terrace, and learn what I could of their history, their social condition, their daily avocations, industrial economy, and religious belief. So, after dinner, I started on foot for a ramble down the valley, and following a winding road up the slope entered the mysterious village from the north a little before sunset, beneath the arching and interlacing boughs of grand old trees. Not a leaf trembled upon its stem; for the zephyrs were asleep, and scarcely a sound was heard but the lowing of cows in the distance, and the footfalls of strange-looking men and women,[5] seen here and there in the village, moving with quick and earnest pace in their daily walk of duty. Looking down into the valley where the golden light of the evening sun lay warm and harmonizing, the sweet words of Gray came out from the closet of memory, and murmured on the lips—[illus. 2]

> "The curfew tolls the knell of parting day,
> The lowing herds wind slowly o'er the lea,
> The plowman homeward plods his weary way.
> And leaves the world to darkness and to me."[6]

As I walked into the village, serenity and peace seemed to pervade the very air! Placidity dwelt upon every face I met. And there were children, too, with cheerful faces peering out from their broad hats and deep bonnets, for they were all dressed like old men and women. I marveled at the sight of children in that isolated world of bachelors and maidens, forgetting that it was a refuge for orphans who were unsheltered in the stormy world without. [illus. 3]

It was Saturday evening. The weekly toil of the community had ceased,

5. See illus. 1. Shaker doctrine dictated the rejection of all worldly fashions, including those of clothing and personal adornment. In practice this meant that the Shakers continued to wear simple clothes in a basic style derived from that of rural New York/ New England between the years 1805 and 1815 (Priscilla J. Brewer. *Shaker Communities. Shaker Lives* [Hanover, N.H., 1986] p. 37). Their costumes were modified slowly (shoe laces were substituted for buckles, etc.) but were sufficiently out of date to appear "strange." It is characteristic of the Shakers that their emphasis on simplicity involved a strong admixture of traditionalism and uniformity: Children and adults were all dressed in the same colors and styles for the same occasions and seasons.

6. Thomas Gray (1716–71), "Elegy Written in a Country Churchyard" (1751), lines 1–4.

and a Sabbath stillness brooded over the populous town. Immense dwellings filled with men and women, and extensive workshops supplied with choicest implements, lined the one broad street. Order and Neatness there held high court with a majesty I had never before seen. The very dust in the road seemed pure, and the virtue "next to godliness"[7] was apparent upon every stone.

Near the centre of the village is a large brick building, painted a chocolate color, in the lower part of which is the Office and Store of the community.[8] There I found several of the brethren and sisters, who received me kindly, and at my request they directed me to the dwelling of Elders Bushnell and Evans,[9] two of the principal men in the village. To them I frankly stated the object of my visit, and was cordially invited to partake of the hospitalities of the community, while I remained among them. An excellent supper was prepared for me, and early in the evening I returned to the family at the store, where I passed the night.

There I found Edward Fowler, the chief business-man of the Society,[10]

7. That is, cleanliness, from John Wesley (1703–91), the English founder of Methodism, Sermon 92, "On Dress": "Certainly this is a duty, not a sin. 'Cleanliness is indeed next to Godliness.'"

8. See illus. 3.

9. Elder Richard Bushnell (1791–1876?). In 1856 he was Head Elder of the North or Gathering Family at New Lebanon, the Family charged with the teaching and training of novitiates. In 1858 he was called from the North Family to the Ministry in the Church ·Family, the four Elders (two men and two women) who presided over the eight families of the New Lebanon community. Each Shaker community had its own Ministry, but the Ministry at New Lebanon was also the Lead Ministry, the ultimate spiritual authority for the entire United Society of Believers in Christ's Second Coming.

For Elder Frederick Evans see note 16, p. 65 this book in "Lossing and the Shakers" essay by Gifford, hereafter referred to as Gifford essay.

The office of the Elders of a Shaker family (two men and two women) is not to be confused with that of the Ministry (see note 14, p. 34 this book in "The Shakers" article by Lossing, hereafter referred to as Lossing article). The elders presided over their family "in all things both spiritual and temporal." They were to be accorded unquestioning and confessional obedience, as they would in turn answer to the Ministry from whom they derived "their strength."

10. Edward Fowler (1800–78) joined the Shakers in 1812 and signed the Covenant (see Lossing article n49) when he came of age in 1821. In 1856 his office, according to the records of the Western Reserve Historical Society, was that of Deacon and Trustee. If so, his office was a somewhat unusual combination, and he must have led the double life of a remarkably busy man. As Trustee he would have been appointed by and answerable to the Ministry at new Lebanon, charged with responsibility for the entire community's land-

and had a long and instructive conversation with him respecting the temporalities of the Shakers. While thus engaged, I heard the sounds of music and dancing, and was told that the family (about sixty in number), on the opposite side of the street, were engaged in their usual evening worship.[11] Curiosity at once led me thither. There, collected in a large room devoted to the purpose, were a large number of men and women, engaged in the peculiar religious rites of Shaker family worship. They sang hymns and lively spiritual songs, all of which were accompanied by dances and marches, conducted in an orderly, and, at times, very impressive manner. These exercises were interspersed with brief exhortations by both men and women; and in the general order of the ritual, it was not much unlike their public ceremonials on the Sabbath. There I saw what the eye of the stranger seldom sees.[12] It was a physical "manifestation

holdings, its monies, and accounts, and its business transactions with other communities and with the outside world. In effect, he was the community's principal agent in its economic and legal relations with the World's People. As Deacon, he would have been charged with supervision of the interior economy of one or more of the Families in the community, its house-keeping, agriculture, and industries. Fowler seems to have performed as Deacon for both the Church and Center Families. In that role he would have answered to the Elders of the Families and not directly to the Ministry (as he would have in his office as Trustee).

11. On Saturday evenings each Family at New Lebanon held religious services in a room provided in one of its dwellings. The singing and dancing, together with inspired "speaking," were in preparation for the Sunday morning worship service (which would bring together selected members of the several Families of the community). In the Shaker week at New Lebanon, Monday evening was given to "Union Meetings," informal but well-supervised conversation groups:

> Each Brother was paired with a Sister of similar age, and each union meeting was comprised of four or five pairs of different ages to provide a measure of community intergration. Sisters looked after the clothing needs of the Brothers with whom they were paired, while the Brethren "in return did needful favors" for the Sisters (Brewer, p. 21).

On Tuesday evening came "ritual practice" (that is, dancing); Wednesday evening, singing practice; Thursday, Family religious services; Friday, Union Meetings; and on Sunday, in addition to the community Worship Service, one or two Union Meetings and/or Family worship services as the Ministry or the Elders of the different families decreed.

12. The Shakers exercised considerable control over what "the World's People" or "Adam's Kind" were allowed to see, and infuriated (among a host of others) Charles Dickens in the process (see Flo Morse, *The Shakers and the World's People* [Hanover, N.H., 1987], pp. 184–87). Few outsiders were admitted to Family worship services before the opening trend of the 1850s; and even the usually public Sunday worship services were

of the power of God,"[13] as they call it. One of the younger brethren, standing in the middle of the room, stretched out his arms and commenced whirling, not rapidly, but steadily, and continued to turn, as if upon a pivot, at least an hour, without cessation, the recipient of the "gift" being apparently unconscious of all that was passing around him. Except in costume, he strongly resembled a whirling Dervish, such as travelers frequently see in the East. This family worship continued about an hour and a half, when I retired to the room assigned me, filled with new emotions, for I was in the midst of social and religious novelties.

The Sabbath dawn was brilliant, and the beauty of the day was memorable. Opposite my lodgings was the house for public worship, [illus. 4] a spacious frame building, painted white, with an arched roof. At its southern end is a smaller building, which they call the Porch, in which the chief ministers, two men and two women,[14] reside. This edifice,[15] built about thirty years

closed during seasons when mystical experiences were particularly frequent and community excitement intense. In the period from 1837 through the mid 1840s, for example, the Sunday meetings were closed for long periods because there was an extraordinary communal outburst of visions and revelations—what Isaac Youngs in his journal called "a new era . . . as the windows of heaven and the avenues of the spirit world were opened," an era which the Shakers called variously "Mother Ann's Second Appearing" or "Mother's Work." As the "manifestations" in this era declined, some Shakers felt disspirited by the promise of a great "ingathering" that had not been fulfilled; others felt (as Lossing recorded in his notebook) that "purity having increased, the intensity is not so great."

13. Or "a gift of the spirit." In Shaker experience these "manifestations" took various forms: visitations from the spirits of the dead, trance states, visions, revelations in the form of messages "in tongues" or music, gift drawings (automatic painting under the influence of a guiding spirit), and the sort of physical or dance seizure of the body ("the whirling gift") which Lossing witnessed. The Shaker leadership was particularly concerned to distinguish between manifestations that were self-induced or induced by group contagion and manifestations induced by Holy Mother Wisdom. Jonathan Edwards had faced similar psychological/spiritual puzzlers during the Great Awakening. The Shaker Elders were as uneasy as Edwards had been about their ability to distinguish spiritual from worldly manifestations. Understandably they were reluctant to share even those manifestations they regarded as spiritual with the World's People who could and did so easily misconstrue the attendant behavior to the detriment of the Shakers.

14. "The Holy Anointed at Holy Mount (or New Lebanon) are called and chosen to stand as the first and leading Ministry, in the Zion of God upon earth." The four Ministers (two men and two women) at New Lebanon were the supreme judges and leaders of the New Lebanon community and of the entire Millennial Church. They made and altered the rules and regulations which the Elders of each Family were to administer.

ago, is a few yards from the first Shaker meeting-house erected in Lebanon, and which is yet standing.[16]

The hour for the commencement of worship was half past ten. Half an hour earlier a long wagon arrived, in which were two brethren and several sisters from the "East Family,"[17] who reside partly over the mountain. At the same time vehicles came with visitors from Lebanon Springs, and soon the seats between the entrance doors, called the "lobby," was filled by "the Gentiles,"[18] the sexes being separated, the men on the left of the women. The floor, made of white pine, was as clean as a dining table. On the side of the

They lived apart, "in no wise blending in common with the rest of the people," and having little or no contact with the World's People. When religious services were public, the Ministry did not attend. Rather, they monitored the ceremonies from their quarters in the Meeting House through special louvered windows that opened into the meeting room. Those windows are visible above the doors at the far end of the room in illus. 5a, b, and c.

15. The Meeting House was built in 1824. Architecturally, it is rather simple and traditional in form, but it was something of an engineering triumph as an enclosure of a large, uninterrupted, and well lighted space, 80 feet long by 65 feet wide, with a segmental plaster ceiling suspended 25 feet above the floor. An impressive system of laminated trusses supports the gently curved ceiling and the more sharply curved roof. When the Darrow School decided to remodel the building into the school library in 1959, the remarkable structure was discovered to be still sound. See *Architectural Forum* (December, 1962) 117:12, pp. 124–27.

16. The first Shaker meetinghouse (1786–87) was the first not only at New Lebanon but also in the entire Shaker enterprise. It was designed and built under the direction of Brother Moses Johnson (1752–1842), a masterbuilder from Enfield, New Hampshire, who had become a Shaker in 1782. In the following years, Johnson was responsible for the construction of nine more Shaker meetinghouses in Shaker communities in the northeast. The first meetinghouse at New Lebanon was moved and converted into the Seed House in 1824. See illus. 16.

17. Each Shaker community was organized as an "Order of Families." At New Lebanon the adjoining Church and Center Families (which Lossing visited) were the core of the community with the East Family to the east over a shoulder of Mount Lebanon. North along the slope from the Church Family was the North or Gathering Family. To the south, the Second and South Families plus the Upper and Lower Canaan Families in nearby Canaan, New York.

18. Lossing borrowed the term Gentiles from the Mormons about whom he had earlier written for *Harper's* (April, 1853). The Shakers called outsiders "the World's People" or "Adam's Kind," strangers to "the Zion of God upon earth," those locked in a life of "generation" and destined for "the second death" because they had not yet received the "regenerative" revelations of Christ, the second Adam, and Mother Ann, the second Eve.

room opposite the seats of the strangers were rows of movable benches, and upon them the sisters who came from a distance began to gather, after hanging their bonnets upon wooden pegs provided for the purpose. In the ante-rooms on the left, the brethren and sisters of the village were assembled, the sexes being separated. At the appointed hour they all came in in couples, stood a moment in silence, and then sat down, the men and women facing each other. Adults and children were dressed precisely alike. With the exception of the resident elders and some visiting brethren, the men were in their shirt sleeves. Their Sunday costume of pantaloons of blue linen, with a fine white stripe in it; vests of a much deeper blue, and plain, made of *linsey-woolsey* (woolen and linen); stout calf-skin shoes and gray stockings. Their shirt-collars and bosoms are made of cotton, like the body; the collar is [illus. 5] fastened with three buttons and turned over. The women wear, on Sunday, some a pure white dress, and others a white dress with a delicate blue stripe in it. Over their necks and bosoms were pure white kerchiefs, and over the left arm of each was carried a large white pocket-handkerchief. Their heads were covered with lawn caps, the form of all, for both old and young, being alike. They project so as to fully conceal the cheeks in profile. Their shoes, sharp-toed and high-heeled, according to the fashion of the day when the Society was formed, were made of prunella, of a brilliant ultramarine blue. Such was the appearance of the worshipers in the presence of at least six hundred strangers, attracted there by curiosity.

The worshipers soon arose, and approached from opposite ends of the room, until the two front rows were within two yards of each other, the women modestly casting their eyes to the floor. The benches were then instantly removed. There they stood in silence, in serried columns like platoons in military, while two rows of men and women stood along the wall, facing the audience. From these came a grave personage, and standing in the centre of the worshipers, addressed them with a few words of exhortation. All stood in silence for a few minutes at the conclusion of his remarks, when they began to sing a hymn of several verses to a lively tune, and keeping time with their feet. In this, as in all of their songs and hymns, they did not pause at the end of each verse, but kept on without rest and with many repetitions until the whole hymn was completed. Elder Evans then came forward, and addressing a few words to the audience, asked them to regard the acts of worship before them with respectful attention. This request was unnecessary, for there was nothing in the entire performance calculated to elicit any other than feelings of deepest respect and serious contemplation.

After two other brethren had given brief "testimonies," [19] the worshipers all turned their backs to the audience, except those of the two wall rows, and commenced a backward and forward march, or dance, in a regular springing step, keeping time to the music of their voices, while their hands hung closely to their sides. The wall rows alone kept time with their hands moving up and down, the palms turned upward. The singing appeared like a simple refrain and a chorus of too-ral-loo, too-ral-loo, while all the movements with hand, foot, and limb were extremely graceful.

The worshipers now stood in silence a few moments, when they commenced singing another hymn, with chorus like the last. When it was ended they retired to each end of the room, the benches were replaced, and the men and women again sat down opposite each other. Elder Evans then came forward, and, in an able discourse [20] of almost an hour, expounded the peculiar doctrines of the Shakers, especially that which relates to the duality of God as male and female, and the second advent of Christ upon earth in the person of Ann Lee, the founder of the Society. [21] When he had ceased all the worshipers arose, the benches were removed, and they formed themselves into serried ranks as before. Then, with graceful motions, they gradually changed their position into circular form, all the while moving with springing step, in unison with a lively tune. In the centre stood twenty-four singers in a circle, twelve men and twelve women; and around them, in two concentric circles, marched and countermarched the remainder of the worshipers, the men three and the women two abreast. A brief pause and they commenced another lively tune

19. Lossing and other witnesses imply that these brief speeches were an organized part of the worship service and that they were not spontaneous but were reports or repetitions of "gifts" and other "workings of the spirit" that had occurred during the week and had been approved for publication by the Elders (see Lossing article n13).

20. This part of the public worship service was obviously addressed more to the World's People than to the Believers, and it was apparently more carefully calculated and given more emphasis under the Elder Evans's leadership than it had been previously. The whole Sunday service seems to have been turned toward the dramatic—a performance designed to impress the public—though this observation should not necessarily call the integrity of the Believers' worship in question. The phrase, "the Elder Evans's leadership," needs to be qualified. What was said and done during these public Sunday services was, I assume, closely monitored by the Ministers from their "coign of vantage" behind the louvered windows at the end of the hall, and the Elder Evans's initiatives must have enjoyed their tacit if not explicit approval.

21. The duality of God as Almighty God and Holy Mother Wisdom (and the duality of His Messiahs) was central to Shaker doctrine. For Ann Lee, see pp. 53ff. of Lossing's article and the accompanying notes.

and march, all keeping time with their hands moving up and down, and occasionally clapping them three or four times in concert. The women were now three and the men two abreast. When the hymn ceased, with a prolonged strain, they all turned their faces toward the inner circle of singers.

After another pause the worshipers commenced a hymn in slow and plaintive strain. The music was unlike any thing I had ever heard; beautiful, impressive, and deeply solemn. As it died away, the clear musical voice of a female was heard from the external circle, telling, in joyful cadence, how happy she felt as a member of that pure and holy community. To this many among the worshipers gave words of hearty concurrence. Another sweet female voice then commenced a hymn in which "Mother Ann" was celebrated.[22] The entire body of worshipers formed into a single line, marched slowly around the central circle of singers, and as the strain ceased their hands fell gracefully to their sides, their bodies were inclined gently forward, and their thin hands were slowly raised and clasped over the waist.

After a brief pause they commenced singing a lively spiritual song. The worshipers now formed four circles, with the singers as the central one, and held each other by the hand, the men and women separately. These circles symbolized the four great Dispensations—the first from Adam to Abraham; the second from Abraham to Jesus; the third from Jesus to "Mother Ann"; and the fourth the present, which they hold to be the millennial period.[23] In

22. In early Shaker worship services these interruptive solos would have been "gifts" (see Lossing article n13) as they still were in the more private Family worship services in the 1850s. Here it seems fairly clear that the soloists have been chosen and their parts in the service rehearsed.

23. The choreography of this "Ring Dance" apparently evolved from simple Ring Dances in the 1840s, and the doctrine which it illustrated, while attributed to Mother Ann, was probably elaborated after her death. The First Dispensation or Cycle, from Adam to Abraham, was the period of relative Darkness after the Fall of Man, marked by the destruction of all humanity except Noah's family in the Flood. This doctrine is based on an interpretation of Paul's assertion, "Nevertheless death reigned from Adam to Moses," Romans 5:14. The Second Dispensation began with the revelation to Abraham of the Lord's "covenant"—that Abraham's "seed" would be a "chosen people" in a "promised land" (Canaan), Genesis chapters 12–25. The Third Dispensation was announced by the appearance of the male Messiah, "For as in Adam all die, even so in Christ shall all be made alive," I Corinthians 15:22. But in the Third Dispensation backsliding and unregenerate man realized not the Kingdom of Christ but the Kingdom of the Antichrist. The Fourth Dispensation, the Millennium, was to be realized at the Second Coming. From the Shaker point of view that Dispensation had been ushered in

this hymn they sang of UNION.[24] as exhibited by their linked hands; and when it had ceased they all lifted up their hands, and gave a subdued shout—the shout of victory—the final victory of Christ in all the earth, and the triumphs of the Shaker, or Millennial Church.

Three or four more songs and hymns, with graceful dances or marches, and the ceremonials drew to a close. While singing the last sweet song, the men and women took their respective places at each end of the room, and stood facing each other. Elder Evans then addressed a few words of encouragement to them, and stepping forward, thanked the audience [illus. 6] for their kind attention, and informed them that the meeting was closed.

From that house of strange worship every "Gentile" seemed to depart with serious feelings. Whatever may have been the scenes among the Shakers in former times or in other communities, of which many have spoken with contempt and ridicule,[25] it can not be denied that their public worship at Lebanon is dignified, solemn, and deeply impressive. We may differ from them in opinion as to its propriety, but we must accord to them great earnestness and sincerity. Their songs and hymns breathe a pure and Christian spirit; and their music, unlike any to be heard elsewhere, captivates the ear because of its severe

by Mother Ann, whose mission was to complete the revelation of God to man. Each of these Dispensations or Cycles had its own heaven and its own hell, but in the Millennium all the heavens were to merge, as were the hells, though the hells were not regarded as permanent states of residence (except for the souls of a few arch-sinners). Most of those in hell were expected to "grow in soul" under the guidance of Shaker missionaries sent out from heaven. See Lossing article n37.

24. "As Union is the distinguishing characteristic of the true followers of Christ; so it is an essential part of the worship of God," [Calvin Green], *A Summary View of the Millennial Church or United Society of Believers* (Albany, New York, 1823) p. 85.

25. The suspicion with which the World's People look upon any community that practices separation and withdrawal was intensified in the case of the Shakers by what appeared to be a wild lack of restraint in their worship and in their claims to revelatory and mystical experience. These "excesses" in turn led to public suspicion that celibacy was preached to disguise orgy in practice. Nor was distrust alleviated when the economy of the Shaker communities gradually proved itself so much more successful than the farm economy of its neighbors. Shaker converts, if they signed the Covenant, were required to give all their property to the Millennial Church where it became part of a consecrated "whole," indivisable, so that converts who left couldn't carry away their initial doweries. This, plus occasional hassles over children committed to their care, were frequent sources of public and legal irritation at the Shakers, as was the Shaker commitment to pacifism and non-resistance, a commitment which was, in times of national crisis, regarded as "treason."

simplicity and perfect melody. Their movements in the dance or march, whether natural or studied, are all graceful and appropriate; and as I gazed upon that congregation of four or five hundred worshipers[26] marching and countermarching in perfect time, I felt certain that, were it seen upon a stage as a theatrical exhibition, the involuntary exclamation of even the hypercritical would be, "How beautiful!" The women, clad in white, and moving grace-fully, appeared ethereal; and among them were a few very beautiful faces. All appeared happy, and upon each face rested the light of dignified serenity, which always gives power to the features of women.

On leaving the house of worship I was invited to the dwelling of the preacher,[27] and there I spent the afternoon and evening with him, and some of the brethren and sisters, in pleasant conversation, the chief topic of which was their doctrine and discipline. They accept the Scriptures of the Old and New Testament (our common version) as the true record of the revelation of God [illus. 7] to man, and appeal to them for all the proofs of the divinity of their great fundamental doctrines of the duality of God's nature as male and female, and the second appearing of Christ in the person of Ann Lee.[28] From the Scriptures they also draw abundant evidence of the necessity of *celibacy*[29] to the

26. The population of the New Lebanon Shaker community was four hundred ninety-one in 1850, and it peaked at five hundred fifty in 1860 (Brewer, pp. 216–17). But even if there were roughly "500 persons" (Lossing, this text) in the community in 1856, there is little reason to think that the entire community journeyed to the Church Family for this program of public worship. In practice only selected groups from the other Families joined the Church family for Sunday worship (which was in part a performance for the tourists from the hotels at Lebanon Springs). Those remaining in their own Families would have had private worship services. Lossing's notebook estimates "say 130 women, and 140 men and boys" in attendance at the Sunday morning service.

27. The preacher: since there was no such office in the Shaker community and since the Ministry did not hold discourse with the "World's People," Lossing obviously means Elder Frederick Evans who "preached" what the worldly audience would have regarded as the Sunday sermon and whose emphasis on carrying the Shaker message to the world made him look and act like a preacher. The assumption that Lossing spent the rest of Sunday with Evans is supported by Mrs. Helen Lossing Johnson's recall that her father had spoken of extended discussions with Evans (George J. Finney, unpublished essay, "A Visit to the Shakers: Lossing not Whitman" [December, 1940] p. 8).

28. For the second appearing of Christ in the person of Mother Ann, see Lossing article n21.

29. Celibacy, which evolved as a centerpiece of Shaker doctrine, was one of Mother Ann's fundamental tenets. It was based upon several passages in the Gospels, notably Luke 20:34–35, "And Jesus answering said unto them [the Sadduces], the children of this

full possession of a true Christian life. In my allotted space, I can only give a brief summary of their faith.

They have no creed,[30] because they believe that the operations of the Divine light are unlimited.

They believe that *The Christ,* a holy spirit, came from the immediate presence of God, and entered into and dwelt with Jesus of Nazareth, the most perfect man that ever lived upon the earth. Jesus predicted the second appearance of *The Christ,* when the millennium should commence. According to their interpretation and calculation of the mystical numbers in the prophecy of Daniel, the reign of Antichrist ended and the millennial dispensation commenced in the year 1747, when the work of preparation for the full display of Gospel truth was begun, under the ministration of James and Jane Wardley,[31]

world marry, and are given in marriage: But they which shall be accounted worthy to obtain that world, and the resurrection from the dead, neither marry, nor are given in marriage." (Cf. Matthew 22:30 and Mark 12:25.) The Shakers were unanimous in their affirmation of celibacy as central to their community life, though their individual understandings of that centrality varied widely; see Robley Edward Whitson, ed., *The Shakers: Two Centuries of Spiritual Reflection* (Ramsey, New Jersey, 1983) pp. 156–80.

30. In practice the Shakers had no formal creed and a relatively flexible body of doctrine. The *Millennial Laws* (see Gifford essay n21) dealt primarily with communal organization and behavior rather than with doctrine. The Shakers were committed to the assumption that their doctrines and the laws that governed their practices would continue to evolve toward "purity," that the initial revelations to Mother Ann and her immediate followers in the Parent Ministry were not fixed and final but guidelines in accord with which the presence of "the Divine Light" would be made increasingly more manifest. As Elder Frederick Evans put it: "past Dispensations, and their revelations, can be understood and interpreted aright *only* by means of a present *living revelation*" (*Shakers: Compendium . . .* [New York, 1859] pp. iii–iv). See Robley Edward Whitson, *The Shakers,* passim, for a fine anthology of Shaker theology.

31. The prophecy cited occurs in chapter 12 of The Book of Daniel when the coming of the Millennium is revealed to Daniel, together with the "times" of its coming:

And from the time that the daily sacrifice shall be taken away, and the abomination that maketh desolate set up, there shall be a thousand two hundred and ninety days. Blessed is he that waiteth, and cometh to the thousand three hundred and five and thirty days.

Daniel 12:11–12

The Shakers believed that the true spirit of early Christianity gave way to "the reign of Anti-Christ" in 457 A.D. Thus the 1290 days (counted as years) would be accomplished in 1747; the 1335 in 1792 when, they believed, Mother Ann's "work of establishing the true Church upon earth" ended (see Lossing article n32). The date 1747 is not as firm as Shaker tradition asserts but in or about that year Jane and James Wardley (or Wardlaw), Quakers of Bolton-le-Moors, eleven miles northwest of Manchester, England, came under the

of whom I shall speak presently. *The Christ* manifested in the person of Jesus was the revelation of the *male* nature of God to man; the same manifestation, in the person of Ann Lee, was the revelation of the *female* nature of God to man. Jesus thus became the second Adam, and the head of spiritual generations; and Ann Lee the second Eve, and mother of like offspring. Her work of establishing the true Church upon earth ended in 1792,[32] when, according to their interpretation, the "fullness of time"[33] was accomplished; and those who belong to that Church are the saints who shall "reign a thousand years."[34]

influence of some refugee Camisards, the so-called "French Prophets," radical and visionary Protestants from Cévennes in southern France. French Protestants had been subjected to increasing pressure to accept Catholicism (the State Church) after the revocation of the Edict of Nantes in 1685. The mounting persecution combined with the emergence of an energetic Camisard leadership to trigger a revolt in 1702. The revolt was characterized by a resourceful guerrilla campaign against vastly superior government forces. It was finally put down (1704–5) by a combination of force and deceptive government offers of amnesty to key Camisard leaders. Many of the Camisards, disillusioned by the failure of armed revolt, continued their religious activities underground; and in the years that followed many sought political and religious asylum in England. The Wardleys are said to have responded to the Camisards by breaking with the Quakers and founding the tiny sect (sometimes called the Shaking Quakers) which, with the subsequent addition of Ann Lee (1758ff.) was to evolve into the Shakers. In its beginnings the sect was without creed or doctrine, apocalyptic in its vision, its worship marked by extravagant "manifestations" from the supernatural world.

32. Mother Ann Lee died 8 September 1784 at Watervliet, New York, but the Shakers believed that the living spirit of this "woman clothed with the sun" (Revelation 12:1) remained on earth with the Parent Ministry until 1792. In the course of that eight years the main themes of Shaker doctrine developed quite rapidly, and the communal organization which had its inception under the leadership of Father Joseph Meacham (1741–96) at New Lebanon was institutionalized. Thus the year 1792, while numerologically convenient (see Lossing article n31) also historically coincided with the end of the major formative phase of the Shakers' Millennial Church.

33. After Mark 1:14–15:

Now after that John was put in prison, Jesus came into Galilee, preaching the gospel of the kingdom of God, and saying, The Time is fulfilled, and the kingdom of God is at hand, repent ye, and believe the gospel.

34. Revelation 20:2–6:

And [an angel] laid hold on the dragon, that old serpent, which is the Devil, and Satan, and bound him a thousand years, and cast him into the bottomless pit, and shut him up, and set a seal upon him, that he should deceive the nations no more, till the thousand years should be fulfilled: and after that he must be loosed a little season. And I saw thrones, and they sat upon them, and judgment was given unto them: and I saw souls of

They believe that they, as a Church, possess all of the apostolic gifts;[35] and that all external ordinances, especially those of baptism and the Lord's Supper, ceased with the apostles,[36] and that since their day no man had been truly sent to preach the Gospel until the dawning of this new dispensation. They believe it to be their mission on earth to gather in the elect; and that through Jesus Christ in the true (Shaker) Church God is reconciled to man. They believe that spirits of Shakers have also a holy mission in the future world; namely, to teach the spirits of those who have died out of the Shaker Church on earth the way to a higher sphere of enjoyment, to which alone the true believers ascend. Thus Shakerism is believed to be a sort of normal school for teachers of righteousness and purity in the spirit world.[37]

They believe that no man can be born of God until, in his Church here, he has become assimilated to the character of Jesus Christ, by abstaining from marriage and other defilements; that obedience to that Church increases a man's faith, until he comes to be one with Christ in the Millennial Church state; and that man is a free agent, having the privilege of accepting or rejecting the true light within him, and, consequently, it is in every man's power to be obedient to the faith. They believe that the Gospel of the *first* resurrection—a resurrection from carnal appetites—is now truly preached in the Church, and

them that were beheaded for the witness of Jesus, and for the word of God, and which had not worshipped the beast, neither his image, neither had received his mark upon their foreheads, or in their hands; and they lived and reigned with Christ a thousand years. But the rest of the dead lived not again until the thousand years were finished. This is the first resurrection. Blessed and holy is he that hath part in the first resurrection: on such the second death hath no power, but they shall be priests of God and of Christ, and shall reign with him a thousand years.

35. The apostolic gifts are received through baptism "with the Holy Ghost" which Jesus promised the Apostles just before his ascension (Acts 1:5). The Apostles received that baptism and those gifts in Acts 2 on the Day of Pentecost: the spiritual ability to speak "in tongues," to prophesy, to see visions, to heal the sick, to cast out devils, and to see with "spiritual spectacles" (Lossing article n53).

36. The scriptual basis for this article of faith is Acts 1:5: "For John truly baptized with water; but ye shall be baptized with the Holy Ghost not many days hence." The prophesy is fulfilled in Acts 2.

37. A. J. Macdonald, a Scotch traveller, reported "Heaven is a Shaker Community on a very large scale. Jesus Christ is the head Elder and Mother Ann the head Eldress. . . . Outside of this heaven the spirits of the departed wander about on the surface of the earth (which is the Shaker hell), till they are converted to Shakerism." (Quoted in John Humphrey Noyes, *History of American Socialisms* [New York, 1870] p. 606.)

that all who are born of God according to this new birth shall never taste of the second death.[38] They believe that in the Christian world, outside of the Millennial Church, professed regeneration is partial; that worldly Christians, by retaining the marriage-relation, are not assimilated to Christ in the purity of his character; and as a consequence of not testing the happiness of the first resurrection here they can not escape, in part, the second death.[39]

They believe that the wicked are punished only for a season, except those who fall from the true Church, for whom there is no forgiveness in this world nor in the next. They believe that Christ will never make any public appearance on the earth as a single person, but only in his saints; that the judgment-day is now begun in their Church, that the books are opened, that the dead are now rising and coming to judgment (that is, those who come out from the world, and attain to Gospel purity in the Shaker Church), and that they (the Shakers) are set to judge the world, because their Church has risen above the order of natural generation (discarding marriage), and become as Christ was, and that by this means heaven begins upon earth. They thus lose all their sensual and earthly relations to Adam the first, and come to perceive, in clear vision, the true character of God. And they believe that there is no full salvation for those who are out of the pale of the Millennial Church.

They accept, generally, the doctrines of modern Spiritualism,[40] and affirm that such manifestations have prevailed among themselves ever since the

38. For the second death, see Lossing article n34.

39. The World's People live in what the Shakers called "the realm of generation" while the Shakers live in "the regenerate order." Only by entering the regenerate order here or hereafter will the individual escape "the second death," a probationary period in the Shaker hell until the all-but-inevitable conversion to Shakerism and release from "the second death."

40. Lossing has in mind the widespread interest in and excitement about spiritualism both here and abroad in the 1840s and 50s. A number of publications fed that interest; the most notable of them was by Judge Edmonds and Dr. George Dexter, *Spiritualism* (New York, 1854–55). The authors set out (judicially and scientifically) to validate the claims of spiritualism, and the beliefs thus validated in part explain public interest in the Shakers in this period. The Shakers did "accept" Spiritualism but thought that the World's People had only a shallow experience of it as compared with the intensity and variety of Shaker experience of manifestations and gifts from the spirit world. The world's rising interest in Spiritualism was nevertheless encouraging. It led the Shakers "to expect hordes of new converts" (Brewer, p. 155), the promised and long awaited 'Great Ingathering.' That expectation was to be cruelly disappointed in the slow decline of the Shaker communities in the nineteenth century.

establishment of the Millennial Church. There were special manifestations throughout all of the Shaker societies, for seven years, commencing at Lebanon in 1841. The expressed object of these manifestations was the improvement of the young members of the Church, then gathered in. They finally ceased in 1848, but before the close the spirits informed the Shakers that they would soon reappear in the world; that these manifestations would spread throughout the earth; and that the effect would be to subvert all existing systems of religion.[41] They assert that all of the songs and hymns used in their worship are revealed to them, from time to time, by ministering spirits, and that the singers meet once a week to practice the newly revealed production for the coming Sabbath. The music, also, is given to them in the same supernatural way. Sometimes children will break out into singing a song or hymn never before heard among them.

The discipline of the Church is founded upon the asserted perfection of the leaders or teachers. The ministry at Lebanon[42] consists of four persons, two men and two women, who have equal authority in spiritual and temporal matters. These constitute a sort of bishopric, which includes the communities at New Lebanon, Watervliet (Niskayuna), and Groveland. Lebanon is the central society,[43] and the place where general councils are held. Under the minis-

41. The Shakers called the season of excitement that Lossing describes "Mother's Work." It actually began at the Watervliet (Niskayuna) Community in the fall of 1837, spread to New Lebanon late in that year, and through all the Shaker communities in the course of 1838. There are numerous accounts of these manifestations and gifts from the spirit world: revelations of all sorts, gifts of painting and song and dance, and a host of visitors that ranged from Mother Ann to George Washington and Napoleon. Even tribes of unregenerate Indian ghosts took possession of groups of worshippers and acted out their desire for instruction and salvation. (See Lossing article n12.) It is interesting that this prolonged season of spiritual ferment occurred just as the Shaker leadership was becoming intensely concerned about its inability to keep the young in the fold. The initial energies of Mother's Work came from the young themselves and seemed to promise a renewed commitment to the Millennial Church, but actually the rate of backsliding and apostasy among the young increased in the 1840s (Brewer, pp. 141, 210)! As for the predictions that "these manifestations would spread throughout the earth" (and result in the Great Ingathering), the Shakers were initially disappointed when the predictions were not immediately and dramatically fulfilled in 1848, but they eventually consoled themselves with the belief that the Great Ingathering was only awaiting "the fulness of time" (Galatians 4:4).

42. See Lossing article n14.

43. While each Shaker community had a Ministry which presided over the Order of

try, who have supreme control, and possess the power of naming their own successors in office, are the elders and eldresses, the sexes, in all cases, holding an equal position. The Lebanon community, consisting of about five hundred persons,[44] is divided into eight families,[45] for the sake of convenience, in each of which are two elders and two eldresses, who have the entire direction of the affairs of the family, and to whom unquestioning obedience is given. The Society is a moral and religious institution, based upon the *twelve* Christian virtues (the twelve gates of the New Jerusalem),[46] namely, Faith, Hope, Honesty, Continence, Innocence, Simplicity, Meekness, Humility, Prudence, Patience, Thankfulness, and Charity; and upon *seven* moral principles (seven golden candlesticks),[47] namely, Duty to God, Duty to Man, Separation from the World, Practical Peace, Simplicity of Language, Right Use of Property, and a Virgin Life.

All persons who unite with the Society must do it voluntarily. The rules and regulations are all laid before them, and it is impossible for a man, with his eyes thus open, to be deceived. The members are divided into three classes, the novitiate, the junior, and the senior class.[48] The first includes those who,

Families and while each geographical grouping of communities constituted a Bishopric, all the Ministries in turn answered to the Lead Ministry at New Lebanon; see Lossing article n14.

44. The population of the Shaker community at New Lebanon was 491 in 1850 and peaked at 550 in 1860, four years after Lossing's visit (Brewer, pp. 216–17).

45. See Lossing article n17.

46. Revelation 21:10–12, 21:

And he carried me away in the spirit to a great and high mountain, and shewed me that great city, the holy Jerusalem, descending out of heaven from God, Having the glory of God: and her light was like unto a stone most precious, . . . And had a wall great and high, and had twelve gates, and at the gates twelve angels, and names written thereon, which are the names of the twelve tribes of the children of Israel. . . . And the twelve gates were twelve pearls; every several gate was of one pearl: and the street of the city was pure gold, as it were transparent glass.

47. Revelation 1:10, 12–13:

I was in the Spirit on the Lord's day, and heard behind me a great voice, as of a trumpet. . . . And I turned to see the voice that spake with me. And being turned, I saw seven golden candlesticks; And in the midst of the seven candlesticks one like unto the Son of man, clothed with a garment down to the foot, and girt about the paps with a golden girdle.

48. These categories evolved from Father Joseph Meacham's preliminary organization of the Church in 1788. He established three "courts" on the model of the Jewish temple: an inner sacred court ("the senior class"), a junior court (probationers) and an outer

by faith, come into a degree of relation to the Society, but who choose to live in their own families, and manage their own temporal concerns. These are owned as brethren and sisters in the Gospel, so long as they live up to its strict requirements of purity of life. The second class consists of those who, having no families, join the Society, but retain the lawful ownership of their private property. They are a sort of probationers and may leave when they please, it being stipulated by written contract when they enter, that they are to receive no pecuniary reward for their services; and also, that, in the event of their presenting property to the Society, it can not be reclaimed when they leave. The third class consists of those who, after long experience, are prepared to enter fully into a united and consecrated interest. This class constitutes what is called church order, or church relation. This relationship is formed after the most mature deliberation, and is binding, because, according to the laws of justice and equity, there can be no ground for retraction. They dedicate themselves, and all they possess, "to the service of God and the support of the pure Gospel, forever."[49] Minors may be admitted as covenent members of this class or order, and when of age may be received into full membership.[50] These covenants are fair and honorable; and it is alleged that during a period of sixty years, since the permanent establishment of the Society, there has never been any legal claim entered for the recovery of property presented to the community.[51]

court (those such as the Trustees who handled contacts with the World's People). In 1799 this was modified by the addition of a novitiate or "gathering" order such as Lossing describes, communicants of the Millennial Church who lived outside the Shaker communities and continued to manage their own worldly affairs. The junior order or "family relation" (those who lived in the community and under its rules though not yet fully committed) and the novitiate represented two stages of learning and probation.

49. Upon entry into the inner court or senior class, the probationer was required to sign the Covenant (from which Lossing paraphrases). The Covenant was to be signed "Voluntarily and as a Religious duty." It stipulated that the individual contribute his property to "the Joint Interest of the Church" and committed him to a life of "duty" and "obedience."

50. This is not entirely accurate. Minors could be admitted to probationary membership (in the Junior Order) if they and their living parents or guardians so desired, and they could sign a promise to enter the inner court or senior class when they came of age (at twenty-one). But the promise was not binding, and probationers were not full members of the Church until they signed the Covenant after becoming twenty-one.

51. This is also somewhat inaccurate. It is not true that no legal claims were entered against the Shakers. Several of those who dropped out or who were expelled from the

Obedience, as we have observed, is the great law of the Society. The leaders have absolute authority, and the people implicitly obey them. To them the laity make confessions of all their sins:[52] and they believe that the ministry, by means of the "Gospel Glass of Perfection,"[53] can not only see through and through every member of the Society, but can behold the state of the dead, and survey the whole world of spirits, good and bad. Such, in brief, are the leading doctrines of the Shakers, and the main features of their organization and discipline.

The management of the temporal affairs of the community is committed to trustees, who are appointed by the ministry and elders, and these are legally invested with the fee of all the real estate belonging to the Society. They transact all commercial business; and it is the unanimous testimony of those who have had dealings with them, that no men are more just and upright than they.

Church in the course of the nineteenth century did bring suit to recover their "share" of the "one Joint Interest" which the Covenant guaranteed (or to claim wages for services rendered while they were members). It is true, however, that the courts tended to side with the Shaker communities and to turn back challenges to the Covenant. This sympathetic response to the Shaker position is interesting because from a worldly point of view the Covenant appeared to grant the individual a legal share of the communal property, but from the Shaker point of view the property was "a consecrated whole," and the Covenant granted the individual a religious (not a legal or financial) share of the whole. In practice the Shakers were inclined to grant those who departed some sort of severance pay or endowment (clothes and a bit of personal property, a set of tools, etc.). The courts were not as sympathetic to the Shakers when the challenges from the World's People involved the custody of children. In many of those cases the courts found for the parents or guardians. See Carol Weisbrod, *The Boundaries of Utopia* (New York, 1980); and Mary L. Richmond, *Shaker Literature: A Bibliography,* 2 vols. (Hanover, New Hampshire, 1977), "An Annotated Bibliography of the Reported Decisions of the Courts . . . Relating to the Shakers," compiled and edited by Gerard C. Wertking, vol. I, pp. 247–53.

52. Before entering any of the Church's courts the individual had to make a full confession of his past and all his sins—to one of the Elders if a man, to one of the Eldresses if a woman. The confession was not regarded as confession to a religious superior but as confession "in order" (before God with the Elder or Eldress as witness). Individual members were expected (required?) to confess their sins "in word, thought, or deed" several times a year in the presence of the appropriate Elder or Eldress.

53. The image of the "spiritual spectacles" which enable the Ministry and the Elders to see spiritual things and not to be deceived by false spirits or lying confessions is recurrent in Shaker literature and tradition. It is one of the "Apostolic Gifts" and is based on the way Peter sees through the lies and deceptions of Ananias and his wife Sapphira in Acts 5:1–11. See Lossing article n35.

The chief business trustee of the Lebanon community, and whose name is best known abroad, is Edward Fowler,[54] a middle-sized man, about sixty years of age. With him I visited the various industrial establishments. These are situated in convenient places in various parts of the village. All of them are supplied with the best implements, and are conducted in the most perfect manner. I can do little more, in this paper, than give a bird's-eye view of them.

The Herb House,[55] where the various botanical preparations are put up for market,[56] is a frame building in the centre of the village, one hundred and twenty feet in length, and forty feet in width; and two stories and an attic in height. There are some spacious out-houses connected with it. The lower part is used for the business office, storerooms, and for pressing and packaging the herbs and roots. The second story and attic are the drying rooms, where the green herbs are laid upon sheets of canvas, about fourteen inches apart, supported by cords. The [illus. 8] basement is devoted to heavy storage and the horse-power by which the press in the second story is worked. That press, seen in the engraving,[57] is one of the most perfect of the kind. It has a power of three hundred tons, and turns out each day about two hundred and fifty pounds of herbs, or six hundred pounds of roots, pressed for use. This performance will be doubled when steam shall be applied to the press. The herbs and roots come out in solid cakes, an inch thick, and seven and a quarter inches square, weighing a pound each. These are then taken into another room, where they are kept in small presses, arranged in a row, so as to preserve their form until placed in papers and labeled. During the year 1855 about seventy-five tons of roots [illus. 9, illus. 10] and herbs were pressed in that establishment. About ten persons are continually employed in this business, and occasionally twice that number are there, engaged in picking over the green herbs and cleansing the roots brought from the medicinal fields and gardens. The extra laborers are generally females. These fields and gardens cover about seventy-

54. See Lossing article n10.

55. The Herb House (illus. 9) in the Center Family at New Lebanon was constructed in the 1830s and destroyed by fire in 1875.

56. The principal commercial enterprises in the Church and Center Families at New Lebanon were medicinal herbs, roots, and extracts, and packaged garden seeds (a Shaker first). Each of the Families in a Shaker community was expected to develop its own manufacturing and commercial specialties for trade with other Families in the community, with other Shaker communities and (increasingly in the course of the nineteenth century) with the outside world.

57. See illus. 8a.

five acres, a portion of which is devoted to the cultivation of various herbs and vegetables for their seeds.

The Extract House,[58] in which is the laboratory, for the preparation of juices for medical purposes, [illus. 11] is a large frame building, thirty-six by one hundred feet. It was erected in 1850. It is supplied with the most perfect apparatus, and managed by James Long,[59] a skillful chemist, and a member of the Society. In the principal room of the laboratory the chief operations of cracking, steaming, and pressing the roots and herbs are carried on, together with the boiling of the juices thus extracted. In one corner is a large boiler, into which the herbs or roots are placed and steam introduced. From this boiler the steamed herbs are conveyed to grated cylinders and subjected to immense pressure. The juices thus expressed are then put in copper pans, inclosed in iron jackets, in such manner that steam is introduced between the jackets and the pans, and the liquid boiled down to the proper consistency for use. Some juices, in order to avoid the destruction or modification of their medical properties, are conveyed to an upper room, and there boiled in a huge copper *vacuum pan,* from which, as its name implies, the air has been exhausted. This allows the liquid to boil at a much lower temperature than it [illus. 12, illus. 13] would in the open air. In a room adjoining the vacuum pan are mills for reducing dried roots to impalpable powder. These roots are first cracked to the size of "samp" in the room below, by being crushed under two huge discs of Esopus granite,[60] each four feet in diameter, a foot in thickness and a ton in weight. These are made to revolve in a large vessel by steam power. The roots are then carried to the mills above. These are made of two upper and a nether stone of Esopus granite. The upper stones are in the form of truncated cones, and rest upon the nether stone, which is beveled. A shaft in the centre, to which they are attached by arms, makes them revolve, and at the same time they turn upon their own axes. The roots ground under them by this double motion are made into powder almost impalpable. [illus. 14, 15]

In a building near the Extract House is the Finishing Room, where the preparations, already placed in phials, bottles, and jars, are labeled and packed

58. The Extract House or Laboratory in the Center Family (illus. 11) was constructed in 1850.

59. James Long (b. 1817) joined the Shakers in 1830, signed the Covenant when he came of age, and, according to the records of the Western Reserve Historical Society, apostatized in 1860.

60. Esopus granite—from the Catskill Mountains near Esopus (now Kingston), New York.

for market. This service is performed by two women; and from this room those materials, now so extensively used in the materia medica, are sent forth. These extracts are of the purest kind. The water used for the purpose is conveyed through earthen pipes from a pure mountain spring, an eighth of a mile distant, which is singularly free from all earthy matter. This is of infinite importance in the preparation of these medicinal juices. They are, consequently, very popular, and the business is annually increasing. During the year 1855 they prepared at that laboratory and sold about fourteen thousand pounds. The chief products are the extracts of dandelion and butternut.[61] Of the former, during that year, they put up two thousand five hundred pounds; of the latter, three thousand pounds.

The Seed House—the depository of the popular Shaker Garden Seeds—is the ancient church edifice, one of the oldest buildings in the village.[62] This, as we have observed, stands near the new church. Directly in the rear of it is a large [illus. 16] pond, on the margin of which is the Tannery[63] of the Society. At the southern end of the village is the Dairy; and in several other places are workshops, in which brooms, mats, wooden ware, etc., etc., are manufactured. These, and many useful articles of taste, manufactured in the village, are sold at the store to visitors during the summer. Of the minor industrial operations of the community I have not space to make a record. Suffice it to say, that in every department perfect order and neatness prevail. System is every where observed, and all operations are carried on with exact economy. Every man, woman, and child is kept busy. The ministry labor with their hands, like the laity, when not engaged in spiritual and official duties; and no idle hands are seen. Having property in common, the people have no private ambitions nor personal cares; and being governed by the pure principles of their great leading doctrines, they seem perfectly [illus. 17] contented and happy. All labor for the general good, and all enjoy the material comforts of life in great abundance.

61. Extract of dandelion was recommended for stomach and liver ailments and was used in recipes for "Eclectic Liver Pills," "to purify the blood." Oil prepared from the inner bark of butternut tree roots was used in making "Cathartic Syrup" and other soothing syrup recipes. A. W. Chase, M.D., *Dr. Chase's Recipes: Or Information for Everybody* (Ann Arbor, Michigan, 1864) pp. 146, 106, and 160.

62. It was actually the oldest building in the Church Family; see Lossing article n16.

63. The Tannery in the Church Family (illus. 17) was constructed in 1834. The Church Family manufactured a few saddles, but the principal manufactures were harness and other leather products, largely for the use of the eight families of the New Lebanon community.

The Medical Department, under the charge of Dr. Hinckley,[64] appears to be very perfect in it supplies of surgical instruments, and other necessaries. A large portion of the medicines are prepared by themselves; and Dr. Hinckley applies them with a skillful hand, under the direction of a sound judgment. He has a library of well-selected medical works; and the system which he most approves and practices is known as the Eclectic.[65]

With Dr. Hinckley I visited the school for girls,[66] and was surprised and delighted by the exercises there. It was composed of thirty-three girls, varying in ages from four to fifteen years, dressed in the costume of the Shaker women, with the omission of the cap, for which a black net was substituted. The system of instruction is the same as that pursued in our [illus. 18] best common schools; and all the children in the community are supplied with a thorough common English education. In fact, nearly the whole Society is now composed of educated men and women; and I may venture to affirm that there is not a community in our land, of equal numbers, where general intelligence

64. Dr. Barnabas Hinckley (1808–61) joined the Shakers in 1821, signed the Covenant when he came of age and became the physician at New Lebanon in 1837 (see illus. 18). He received his medical degree from Berkshire Medical College in Pittsfield, Massachusetts, on 23 November 1858, a little more than two years after Lossing's visit. In its early period the Shaker Church was marked by a commitment to faith-healing (see Lossing article n35) and a prejudice against those whom Father Joseph Meacham called "the world's doctors." But while belief in faith-healing was sustained, Shaker prejudice against physicians gradually declined and was replaced by an interest in Thomsonian medicine (steam baths and herbal remedies) which in turn was consonant with the development of the medicinal herb and extract business in the 1840s and 1850s. By the time of Lossing's visit the Shakers were far more tolerant of "the world's medicine" than they had been at the beginning of the century.

65. Berkshire Medical College in Pittsfield where Dr. Hinckley took his degree was Eclectic ("American" or "New School") in its orientation. The Eclectics attempted to remain individuals and to combine in practice the best of various schools of medicine. They resisted the sequence of fads (for water cures, etc.) that marked the history of medicine in the nineteenth century, rejected the use of mercury and most other mineral substances, and put considerable emphasis on the study and use of native remedies and medicinal plants.

66. The schoolhouse in the Church Family (see illus. 19) was constructed in 1839. The girls in the community attended school for four months each year in the spring and summer; the boys for four months in the winter. Among the early Shakers there had been some suspicion that education would be detrimental to faith, but that suspicion gradually gave way to an increasing emphasis on education in the second decade of the nineteenth century and thereafter.

more largely prevails. They have a library for common use,[67] and at the business office I saw several daily papers.[68] Isolated as they are from the world around them—taking no part in elections or other public affairs[69]—yet they are alive to all its passing events; and I found them generally familiar with social, religious, and political topics of the day.

The reader will naturally inquire, "Whence the origin of this strange people?" I answer, from the depths of obscurity in an English provincial town. Here, in brief, is the record:

During the great religious revivals in Europe, toward the close of the seventeenth century, societies were formed in one or two districts in France, whose members were wrought upon in a very extraordinary manner, both in body and mind. At times they were violently agitated, and with loud voices they uttered warnings of God's wrath, persuasions to repentance, and prophecies of the near approach of the end of all things. Early in the last century some of these found their way into England, where they were known as French Prophets. Disciples gathered around them; and finally, in 1747, James and Jane Wardley,[70] members of the Society of Friends, or Quakers, embraced their views, and formed a small society near Manchester. They at once attracted public attention, and were persecuted. They were considered insane, because they would sit immovable for hours, waiting for "the power of God," and then would commence jumping, whirling, trembling violently, and shouting for joy. Because of these bodily agitations they were called Shakers, and sometimes Shaking Quakers.

In 1758 a young woman of twenty-two, named Ann Stanley, the wife of a

67. The *Millennial Laws* (1845), Part II, Section XI, make it quite clear that "books of the world" were to be admitted into the community only with permission of the Elders and Eldresses of the Family. In practice by the 1850s the censorship in the New Lebanon community was somewhat more relaxed than the *Laws* imply.

68. The *Millennial Laws,* Part III, Section XI:9: "Newspapers shall be received alone by those at the Office, or outer court [that is, by the Trustees and Deacons], and should there be returned and kept, when they have been perused in the family; and none shall come into the family except by the knowledge of the Elders." Here again the *Laws* overstate the proscriptions that would have operated in most Shaker communities.

69. The Shakers were dedicated pacifists and resolute in their refusal to bear arms. They also refused to vote or otherwise participate in the "World's" political institutions, but they did scrupulously abide by court decisions and meet their tax obligations punctually and without complaint.

70. For the French Prophets and the Wardleys, see Lossing article n31.

blacksmith, by whom she had borne four children who had died in infancy, became acquainted with the Wardleys, embraced the new and strange doctrine that marriage was sinful,[71] and was a most earnest devotee. She assumed her maiden name of Lee, severed the marriage relation,[72] and after nine years of severe discipline,[73] and suffering of persecution as a half-crazed fanatic, she professed to have received a revelation from God. Then, although in prison, she boldly opened her mouth as a teacher. She declared that in her dwelt the "Word," the "Christ"; and the doctrine of his second appearance upon earth in the person of a woman became a dogma of the sect.[74] She was acknowledged to be a spiritual mother in Israel, and she is known and revered by her four thousand followers to-day by the appellation of Mother Ann.

With her brother and a few followers Ann Lee came to America in 1774,[75] and in the spring of 1776 they settled at Niskayuna[76] (Watervliet), opposite

71. Ann Lee joined the Wardleys' Shaking Quaker sect in September of 1758. The way Elder Frederick Evans tells the story of Ann Lee's life in *Shakers: Compendium . . .*, pp. 120ff., the narrative sequence suggests that she was married and had borne her four children (three of whom died in infancy, one in early childhood) *before* she joined the Wardleys, but her marriage to Abraham Stanley (or Standerin) did not take place until 5 January 1762 and the last of her children died in October 1766. There is no evidence to suggest that the Wardleys preached "that marriage was sinful" and considerable evidence to suggest that the doctrine of celibacy was Mother Ann's revelatory contribution to the emerging sect in 1770 or immediately thereafter (Evans, p. 131).

72. Evans tidied up Mother Ann's career by implying (but not asserting) that her marriage (and children) predated 1758 so that meeting the Wardleys would be a turning point not only in spirit but also in her life. In fact the relation with Stanley (as Evans admits, p. 141) continued in some fashion until 1774–75 after Mother Ann, her husband and her companions had come to America.

73. The "nine years" is Evans's rhetorical flourish (p. 126), but it is baffling because nine years after 1758 would be 1767 and Mother Ann was not imprisoned until 1772 (for a month) and again in 1773 (for an undetermined period). If, on the other hand, the nine years of "severe discipline" preceded her imprisonment, then this period began in 1763–64, a year or so after her marriage.

74. After her second prison term Mother Ann emerged as the leader of the Shakers, and it is from this time that Evans (and Shaker tradition) date the revelation that Mother Ann was the female Messiah, the Second Appearing of Christ on earth. That tradition seems to have evolved more slowly than the implied back-dating in narrative accounts of her life would suggest.

75. Ann Lee, her brother William Lee, her husband Abraham Stanley, and six other followers sailed from Liverpool 10 May 1774 and arrived in New York City 6 August 1774.

76. William Lee and the others acquired and settled on a tract of land in Niskayuna (Watervliet) eight miles northwest of Albany, New York, in the fall of 1774, but Mother

Troy, New York, where the sect still have a community. Some people charged Mother Ann with witchcraft; and vigilant Whigs, at that opening period of the struggle for Independence, knowing that she preached vehemently against war in every shape, suspected her of secret correspondence with her countrymen, the British. A charge of high treason was preferred against her, and she and some of her followers were imprisoned at Albany in the summer of 1776. In the autumn she was sent as far as Poughkeepsie with the intention of forwarding her to New York, within the British lines. She was released by Governor Clinton in December,[77] and returned to Watervliet, where her followers greatly increased.

In 1780 a wild revival movement occurred at Lebanon, Columbia County.[78] It spread wonderfully among preachers and people. They sought for peace, but could not find it. Some finally visited "Mother Ann" at Watervliet, became convinced that she was possessed of the right doctrine, that she was the "woman clothed with the sun," mentioned in the Apocalypse,[79] and that in her Christ had again appeared upon earth. A flood of converts was now poured into the lap of the Shaker Church. "Mother Ann" became a *Pontifex Maximus*[80]—a very Pope in authority—and a society of believers was estab-

Ann remained in New York City (with or near her husband) until late 1775. She did not move permanently to Niskayuna until the spring of 1776 by which time the relation with Stanley seems to have been "dissolved" (Evans's word in *Shakers: Compendium*, p. 141).

77. Mother Ann and five of her followers were arrested on 26 July 1780 and imprisoned in Albany because their pacifism made the authorities suspect Tory leanings. Mother Ann and another woman were sent to the Commissioners at Poughkeepsie to be passed through the British lines. The others were held in Albany and released in November 1780 when they posted bond for their good behavior. Mother Ann and her companion were released in December 1780 upon order of Governor George Clinton (1739–1812), first governor of New York (1777–1805).

78. The revival, led by Joseph Meacham, actually began in 1779 in a summer-long heave of excitement: the Millennium was at hand. Late in 1779 the communal excitement gave way to depression as it became more and more apparent that the spiritual hopes for Millennium were not going to be fulfilled. Early in 1780 two of the depressed revivalists from New Lebanon happened upon Mother Ann at Niskayuna. That contact opened communication between Niskayuna and New Lebanon and climaxed in the conversion of Meacham (subsequently Father Joseph Meacham) and in the rapid evolution of doctrine and communal organization which was to establish the Millennial Church and its community structures.

79. Revelation 12:1:

> And there appeared a great wonder in heaven; a woman clothed with the sun, and the moon under her feet, and upon her head a crown of twelve stars.

80. *Pontifex Maximus* is Latin for "chief of the priests," the head of the principal college of priests in ancient Rome.

lished at New Lebanon. Having finished her mission, "Mother Ann" died at Watervliet on the 8th of September, 1784, in the forty-eighth year of her age.[81] Her remains rest beneath a little mound about a quarter of a mile from the meeting-house at Watervliet, with nothing to mark the spot but a small rough stone, upon which is inscribed "M. A. L."—Mother Ann Lee.[82] In childhood she was remarkable for her seriousness. At maturity she was rather below the common stature of women, rather thick set, but well proportioned. Her complexion was light and fair, and her eyes blue and penetrating.[83]

The society at New Lebanon grew vigorously, and in 1787 they built quite a spacious house of worship there, which is still standing, and now used, as we have observed, as the Seed House of the community.[84] Other societies have

81. Shaker tradition asserts 29 February 1736 as the date of Mother Ann's birth, but there is no extant documentary proof of that date.

82. "Originally buried on land which did not belong to the Shakers, Mother Ann's body was later disinterred and replaced" (1835) in the Shaker Cemetery, Town of Colonie, Albany County, New York. Dorothy M. Filley (ed., Mary L. Richmond), *Recapturing Wisdom's Valley: The Watervliet Shaker Heritage, 1775–1975* (Albany, New York, 1975) p. 85. Filley continues:

> It was not until 1880 that the gravestones were placed there [in the Cemetery of the Watervliet community], uniform in size and simply marked with the name, date of death, and the age of the deceased, excepting the larger stone of the founder, which reads: "Mother/ Ann Lee/ Born in Manchester/ England/ Feb. 29, 1736/ Died in Watervliet, N.Y./ Sept. 8, 1784."

83. "In childhood she was . . . blue and penetrating."—These sentences were added to the article after the completion of Lossing's final draft (manuscript now in the Huntington Library). They were adapted from one of two sources, either [Calvin Green], *A Summary View of the Millennial Church* (Albany, 1823), pp. 6 and 25; or Elder Frederick Evans, *Shakers: Compendium . . .*, pp. 121–22:

> In her childhood she discovered a very bright and active genius, was remarkably sagacious, but serious and thoughtful (Green, p. 6).
> In childhood, she exhibited a bright, sagacious, and active genius. She was not addicted to play, like other children of her age, but was serious and thoughtful (Evans, pp. 121–22).
> Mother Ann Lee, in her personal appearance, was a woman rather below the common stature of women; thick set, but straight and otherwise well proportioned and regular in form and feature. Her complexion was light and fair, and her eyes were blue, but keen and penetrating (Green, p. 25).
> In appearance, Ann Lee was about the common stature of women. She was thick-set, but straight, well-proportioned, and regular in form and features. Her complexion was light and fair, blue eyes, and light chestnut brown hair. Her countenance was mild and expressive, but grave and solemn. Her glance was keen and penetrating; her countenance inspired confidence and respect. Many called her beautiful (Evans p. 121).

84. See Lossing article n16.

since been planted and are growing in various parts of the Union. They now number eighteen, having an aggregate of little more than four thousand members.[85] The present "Gospel order of the Church" was established in 1792, and from that period the Shakers date their millennial era.[86]

I have endeavored, in this brief sketch, to give a faithful outline-picture of the Shakers, with such drawings of objects of interest as I was enabled to make during a sojourn of two days with them. I am convinced, from observation and from the testimony of their immediate neighbors, that they live in strict accordance with their professions. They are hospitable to strangers, and kind and benevolent toward the community around them. In morals and citizenship they are above reproach; and they are loved by those who know them best. They have been ridiculed and maligned by those who must have been either ignorant or wicked; for it seems impossible for any candid man, after becoming acquainted with their character, to regard them otherwise than with the deepest respect. Surely the sacrifices of the dearest interests of earth are sufficient guarantees of their sincerity. Call it all delusion if you will, the impregnable fact that they have maintained their integrity and their faith for seventy years is vastly significant.

With their social and religious dogmas I have nothing to do in this connection; yet I can not let the occasion pass without quoting from Coventry Patmore's "Angel in the House," the following lines for the consideration of those within and without the pale of the Shaker Church:

"Say what of those who are not wives,
 Nor have them; tell what fate they prove
Who keep the pearl which happier lives
 Cast in the costly cup love?
I answer (for the sacred Muse

85. The eighteen communities were located at New Lebanon, Watervliet (or Niskayuna), and Groveland, New York; Hancock, Tyringham, Harvard, and Shirley, Massachusetts; Enfield, Connecticut; Canterbury and Enfield, New Hampshire; Alfred and Sabbathday Lake, Maine; Union Village, North Union, Watervliet, and Whitewater, Ohio; South Union and Pleasant Hill, Kentucky. The estimated population conforms to other estimates from the 1850s, but the total population of Shakers was in decline. "The traditional view that the sect maintained a high level of membership until at least the Civil War was manifestly incorrect" (Brewer, p. 156).

86. By 1792 the organization of the original Shaker Families and the appointment of Elders and Eldresses to preside over them had been completed at the New Lebanon community.

Is dumb), Ill chance is not for aye;
But who, with erring preference, choose
 The sad and solitary way,
And think peculiar praise to get
 In Heaven, where error is not known,
They have the separate coronet
 They sought, but miss a worthier crown.
Virgins are they before the Lord,
 Whose hearts are pure; the vestal fire
Is not, as some misread the Word,
 By marriage quenched, but burns the higher."[87]

87. The quoted lines are from "The Pearl," in *The Angel in the House: The Espousals* (Boston, 1856) pp. 97–98, by the English poet Coventry Patmore (1823–96). Patmore's poem is a lengthy celebration of married love, and it apparently struck the right note because it was very popular in this country in the 1850s and 1860s. Patmore added to the poem for a new edition in 1857 and altered the quoted lines (which first appeared in the 1856 edition). The passage appears in its altered 1857 form in all subsequent editions of *The Angel in the House*.

Lossing and the Shakers

Don Gifford

Benson John Lossing's unsigned article "The Shakers" was composed and illustrated in the leisurely days before the candid camera and instant journalism, but it was nevertheless something of a journalistic first. Lossing's article and his photojournalistic style were to have considerable influence on the way the Shakers and their communities were perceived in nineteenth-century America. Two of the several factors that contributed to the article's timeliness and influence were the quality of Lossing's illustrations and his straightforward, descriptive account of Shaker life, practices, and beliefs. Another of the factors was a new openness on the part of the Shakers toward those they called "the World's People" or "Adam's Kind"; Lossing thus found a community willing to let him see and record more than earlier worldly visitors had apparently been able to see and record.[1] Another factor contributed to the influence of Lossing's article: By the mid-1850s *Harper's New Monthly Magazine* had established itself as the first of the big national illustrated magazines, thanks to developments in the technology of wood-engraving, the high-speed printing press, and the nationwide distribution made possible by the rapidly expanding network of railroads. There had been previous magazine articles about visits to Shaker communities, but they had appeared in what were essentially provincial magazines such as *Knickerbocker* and the *North American Review* and had not been illustrated. Lossing's wood-engravings were thus the first full set of eye-witness illustrations of the Shakers, and they were a prime influence in shaping the American public's visual knowledge of the Shakers. That influence was further extended when Charles Nordhoff re-used twelve (or perhaps thirteen)[2] of Lossing's wood-engravings to illustrate his discussion of the Shakers

1. See Flo Morse, *The Shakers and the World's People* (Hanover, N.H., 1987).
2. See Lossing article n66.

in *The Communistic Societies of the United States* when that book was published by Harper's in 1875.

Benson John Lossing (1813–1891)

Dictionaries of biography usually list Lossing as "an American historian," and, though now all but forgotten, he was from the 1850s to the end of his life the most well-known and popular of American historians, and, as a man before his time, the first of the great American photojournalists. He was not a historian as modern historians conceive and practice that art. He was, by his own assertion, a chronicler and an antiquarian who not only read widely but who also travelled and corresponded widely in search of interviews, documents, memorabilia, and other historical materials. In addition, he was a skilled wood-engraver, an illustrator of some talent, and a successful businessman. He deprecatingly called himself a "scribbler and limner," frequently remarked that he was a travelling human portfolio, and never threw anything away. By the end of his life the three-thousand square foot fireproof studio-library he constructed at his home, The Ridge, on Chestnut Ridge near Dover Plains, New York, was crammed to the rafters with his books and collections of historical materials and memorabilia, collections which included most of the manuscripts, sketches and watercolors of a lifetime.[3]

Lossing's perspective, as he described it, was that of "the American patriot, the philanthropist, and the Christian philosopher,"[4]—meaning by philanthropist a person who was morally and sympathetically generous and benevolent toward all mankind. This combination of benevolent optimism and an insatiable curiosity about the surfaces of the American scene suggests both Lossing's strengths and his limitations.

His method was not to research and analyze as much as it was to collect and chronicle in contrast to his contemporaries Henry Adams (1838–1918), George Bancroft (1800–1891), John Lothrop Motley (1814–1877), Francis Parkman (1823–1893), and William Prescott (1796–1859). In spirit and temperament

3. The Anderson Auction Company in New York City catalogued and sold at auction the contents of Lossing's "library" (Autograph Letters, Books, Prints, Broadsides, Pamphlets, Manuscripts, Drawings, and Watercolors). The 6423 "lots," into which the collection was divided were disposed of in eleven sales, four in 1912, two in 1913, two in 1914 and one each in 1917, 1918 and 1925.

4. Benson J. Lossing, "The Mormons," *Harper's New Monthly Magazine* (April, 1853) vol. 6, p. 621.

Lossing shares Bancroft's faith in progress and the implicit assumption that Providence has a special regard for the Republic and its destiny. But he is the polar opposite of a self-questioning historian like Henry Adams, apparently little disturbed by those Gilded Age visions of "modern civilisation" that haunted Adams. As a "patriot," Lossing was quite capable of condemning those who persecuted the Mormons, for example, but he also regarded that persecution as a temporary aberration in an otherwise positive and moral American scene. The chronicler in him did not ask: Is this somehow inherent in the American experience? But as an even-handed philanthropist, he could also regard some aspects of Mormon behavior as provocative. When he faced the task of writing his history of the Civil War, he characteristically admitted the impulse "to bury in oblivion all knowledge . . . of the sorrowful story of a strife among his brethren."[5] Obviously his chronicle of that war denied that impulse in three volumes, but he did not have his view of America darkened as did so many of his contemporaries. After the war he could still feel that the nation was bearing "its precious burden of Free Institutions and Democratic Ideas, as nobly and vigorously as ever."[6] This affirmative openness may have circumscribed the reach of Lossing's historical imagination, but it did wonders for his capacity to gather information from a host of people from all walks of life, most of whom regarded him as "an immediate friend."

Lossing was born in Beekman, New York, a farm community twelve miles southeast of Poughkeepsie, on 12 February 1813. His father, a farmer, died when Lossing was eight months old. His Quaker mother died on 26 August 1824 when Lossing was eleven. His mother's death cut short at three years the only formal schooling he was to have. He worked on farms in the vicinity of Beekman for two years and then was apprenticed to Adam Henderson, a watchmaker and silversmith in Poughkeepsie. One account of his life describes this apprenticeship as "severe,"[7] but that account doesn't seem to jibe with the fact that in June 1833 he married his master's niece Alice Barritt, who shared and helped to shape Lossing's growing interest in literature, history, and the arts. And when he turned twenty-one in the following year he graduated from apprenticeship to partnership with Henderson.

5. Benson J. Lossing, *Pictorial History of the Civil War* (3 volumes, Philadelphia, 1866, 1868) vol. I, p. 3.

6. Ibid., p. 4.

7. "A Biographical Notice of Benson John Lossing, LL. D.," prepared by Nathaniel Paine for The Worcester Society of Antiquity (Worcester, Massachusetts, 1892).

In 1835 Lossing left the partnership to become joint owner and editor of a weekly newspaper, the *Poughkeepsie Telegraph,* the official Democratic paper for Dutchess County, New York; circulation in 1836, two thousand six hundred. In that year Lossing launched, edited and wrote extensively for another publication, the *Poughkeepsie Casket,* a semi-monthly magazine "devoted exclusively to the different branches of polite literature and the arts." The growing public interest in magazines and books illustrated with wood-engravings led Lossing to study that craft in New York City with Joseph Alexander Adams (1803–1880), reputedly the best wood-engraver of his time. Lossing also studied briefly at the school of design connected with the relatively conservative National Academy of Design in New York City.

Lossing's skill as a watchmaker and silver smith, combined with his growing interest in the art of illustration, made him an apt pupil, and in 1838 he moved to the city and started a wood-engraving business of his own. The Worcester "Biographical Notice" describes this as a period of hardship, a description suspect as the obligatory Horatio Alger shadow on a soon-to-be promising career because, as it turned out, the new business was formed just as the great age of illustrated books and magazines was beginning. By the late 1840s Lossing's wood-engraving business was the largest in the city, ready to supply the newly emerging big national magazines (*Harper's New Monthly Magazine,* 1850 ff.). In the meantime Lossing edited and illustrated the *Family Illustrated Magazine,* the first fully illustrated American periodical (weekly, June 1839 to May 1841). He also wrote and illustrated his first book, *Outline History of the Fine Arts* (New York, 1840), volume 103 in Harper and Brothers, *The Family Library.*

During the 1840s Lossing's interest in American history began to develop and bear fruit. In 1843 he expanded his wood-engraving business to include partnership with his brother-in-law Thomas Barritt.[8] The partnership gradually freed Lossing from everyday involvement in the business, and by 1848 Lossing was free to conceive the project which was to crystalize his style as chronicler and illustrator and shape the rest of his career. He proposed to Harper and Brothers that they support the travel necessary to the production of his *Pictorial Field-Book of the Revolution*[9] and Harper's accepted. Lossing had

8. Little is known about Barritt. He was born in Poughkeepsie c. 1822. Largely under his direction by the late 1840s, the wood-engraving partnership flourished until 1869 when it closed its doors. Lossing moved to The Ridge outside Dover Plains, New York, in that year, and Barritt dropped out of sight.

9. Published in thirty serial installments, June 1850 to December 1852.

already published a two-volume history of the Revolution for school children, *Seventeen Hundred and Seventy-Six* (New York, 1846, 1847). For this earlier history Lossing had relied heavily on an impressively thorough reading of secondary sources, but for the *Field-Book* he said he wanted to achieve "accurate chorographical knowledge of our early history" by visually mapping "every important place made memorable by the events of the war."[10] This ambitious project involved over eight thousand miles of travel in the United States and Canada, in the course of which Lossing made sketches for the eleven hundred wood-engravings that were to illustrate the *Field-Book,* interviewed endlessly in search of local fact and legend, and collected autographs, documents and memorabilia. The *Field-Book* was an immediate success, its continuing success interrupted by the loss of the wood-engravings in the great fire at Harper's in 1853. Lossing revised, edited and re-illustrated the text (2 volumes, Harper's, 1855) and launched on a related project, *A Pictorial History of the United States for Families and Libraries* (New York, 1857). Meanwhile, Lossing's first wife, who had shared and helped to shape his interests and who had accompanied him as amanuensis on many of his field trips, died on 18 April 1855. In November of the following year he married Helen Sweet of Dover Plains, New York. She too shared his interests and contributed to his research expeditions, particularly in the preparation of *The Hudson, from the Wilderness to the Sea,* serialized in the *London Art Journal* (1860–61), revised and issued as a book (New York, 1866).

The success of the *Field-Book* established Lossing as *the* popular American historian, and his reputation, combined with his curiosity and his benevolent manner, gave him extraordinary access to people in all walks of life from presidents and cabinet secretaries to obscure local antiquarians and legend-mongers. That air of "access" pervades almost all of Lossing's later works, particularly his *Pictorial History of the Civil War* and *The Pictorial Field-Book of the War of 1812* (New York, 1869). His productivity as chronicler and illustrator, the first American photojournalist, continued unabated through the rest of his life, a life distinguished not only by public success but also by his personal qualities of patriotic optimism and liberal benevolence. Among other things, he is credited with having advocated the ideas that led Matthew Vassar to establish Vassar Female College in 1861; (Lossing was appointed Charter Trustee and Historian of the College in that year). He died at The Ridge on 3 June 1891, survived by his second wife (d. 1911) and their four children.[11]

10. *Pictorial Field-Book of the Revolution* (New York, 1859) vol. I, pp. vii and ix.
11. See Alexander Davidson, Jr., "How Benson J. Lossing Wrote His 'Field-Books' of the Revolution, the War of 1812 and the Civil War" in *Bibliographical Society of America,*

Lossing's Visit to the Shakers (The United Society of Believers in Christ's Second Appearing) at New Lebanon, New York, August 1856

Their strange forms of worship, consisting chiefly in singing and dancing; their quaint costume, their simple manners, their industry and frugality, the perfection of all their industrial operations, their chaste and exemplary lives, and the unsurpassed beauty and picturesqueness of the country in which they are seated, render a visit to the Shakers of Lebanon a long-to-be-remembered event in one's life.[12]

While Lossing was to remember the Shakers in this kindly fashion when he was writing *The Hudson from the Wilderness to the Sea* in 1859–60, he had some reason before his 1856 visit with them to think of them otherwise. In the serialized first edition of the *Pictorial Field-Book of the Revolution* (1850–52) Lossing had mildly deprecated Mother Ann Lee's visionary career and had aroused Shaker ire by mis-identifying her as the daughter of General Charles Lee (1731–82) of the American Revolution. Lossing corrected the mistake about her parentage when he revised and reissued the *Field-Book* in 1855, but he did not change the tone of the treatment of Mother Ann.[13] As late as 1879 some Shakers were still irritated: Elder Hervey L. Eads of the Shaker Community at South Union, Kentucky, an irritable conservative in any event, sent Lossing a presentation copy of his book *Shaker Sermons* (New York, 1879) with an accompanying letter denouncing Lossing's "Life of Anne Lee."[14]

Papers (14 June 1938) vol. 32, pp. 57–64; Amy Ver Nooy, "Benson J. Lossing, Nineteenth-Century Historian and Wood Engraver," *Antiques* (April, 1968) pp. 524–29; Thomas Sweet Lossing, "My Heart Goes Home," *Dutchess County Historical Society, Year Book* (Poughkeepsie, 1946) vol. 31, pp. 53–78; "My Heart Goes Home, Part II" (Poughkeepsie, 1947) vol. 32, pp. 63–82; another brief account of Lossing's life, *Dutchess County Historical Society, Year Book* (Poughkeepsie, 1973) vol. 58, pp. 60–69, is unfortunately not very accurate.

12. Benson John Lossing, *The Hudson from the Wilderness to the Sea* (New York, 1866) pp. 149–50.

13. *Pictorial Field-Book of the Revolution*, vol. II, p. 383n1.

14. I am indebted to George J. Finney for this information; it is based on one of the Lossing catalogues from the Anderson Auction Company, *Americana, the Library of the late Benson J. Lossing*, Part II, books and letters . . . L to Z, June 5–6, 1912; p. 214, item 2065, where Eads' book and letter are listed. Lossing's sketch of Mother Ann Lee's life occurs in the *Field-Book*, vol. 2, p. 383n1. That sketch contains various bits of misinforma-

Lossing's visit to the Church and Center Families of the Shaker Community at New Lebanon, New York,[15] was, he says, "a sojourn of two days." It must have been a busy two days. His article implies that he arrived on a Saturday, and the dating of the watercolors clearly suggests Saturday, 16 August 1856. That evening he visited a worship service in one of the Church Family dwellings. On Sunday he attended a public worship service in the Meeting House at the Church Family and spent the rest of the day in the company of Elder Frederick W. Evans.[16] In the afternoon Evans included Lossing in what sounds like a "Union Meeting," four or five pairs of Brothers and Sisters of different ages who gathered "several times a week to discuss topics of general community interest" in order to foster "spiritual union" between the sexes and in the community at large.[17] Evans also talked to Lossing, apparently at some length,

tion such as the "fact" that she died at the age of eighty-four in 1784. The outline of Mother Ann's life in the *Harper's* article conforms more closely to Shaker accounts of her life. However, Elder Eads might well have objected to that life too because it so clearly reflects the views of Eads' adversary, Elder Frederick Evans (see Gifford essay n16).

15. The community was renamed Mount Lebanon when a U.S. Post Office was established there in 1861.

16. In 1856 Evans (1808–93) was Elder of the North or "Gathering" Family (the family charged with inducting and indoctrinating new members) at New Lebanon. Born in England, he came to the United States in 1820. When he joined the Shakers in 1830, he was a dedicated believer in the social collectivism advocated by the English reformer Robert Owen (1771–1858), but Evans had been disappointed by his observations of Owenite and other utopian communities, and he turned toward the Shakers. He was initially attracted by the success of Shaker socialism rather than by Shaker religion, and by the 1850s he was possessed by a strong desire to bring the Shaker message to the "World's People." He was a key figure in the opening to the World that was taking place at New Lebanon during the 1850s, and "by the late 1860s and early 1870s Evans had become the sect's *de facto* public spokesman, although he never became a member of the Lead Ministry" (Priscilla J. Brewer, *Shaker Communities, Shaker Lives* [Hanover, New Hampshire, 1986] p. 192). His emphasis was on publishing Shaker doctrine and on advertising the success of Shaker communal organization (Shaker socialism) in the immediate interest of recruiting Shakers and in the long range interest of encouraging broad-based social reform among the World's People. He produced over one hundred eight publications in the course of his life, and his correspondents included the élite of world reformers, among them Count Leo Tolstoi (1828–1910) and Henry George (1839–97). In all probability he wasn't elevated to the Lead Ministry because he was more useful to the Shaker cause as public spokesman than he would have been in the administrative privacy of the Ministry (see Lossing article n14).

17. Brewer, p. 21.

about Shaker history and doctrine and about the life of Mother Ann Lee. Lossing's article includes sustained passages clearly all-but-dictated by Evans[18] whose progressive views and reform initiatives were suspect to many of his more conservative Shaker contemporaries.

In the course of his stay Lossing also interviewed Edward Fowler, the chief Trustee at the Church Family, who was in charge of the Shaker Community's secular and economic relations with the World's People. And Lossing spoke with several other Shakers: with the chemist, Brother James Long; with the physician, Dr. Barnabas Hinckley; with Brother Isaac Newton Youngs (all of the Center Family at New Lebanon); and with Brother Daniel Sering, a visitor from the Shaker Community at Union Village, Ohio. In addition, Lossing made sketches for the nineteen or more watercolors he produced to guide the wood-engravers at Lossing-Barritt in their preparation of the illustrations for his article in *Harper's*.

All the extant watercolors bear the date 18 August 1856 (a Monday) except "The Dance" which is dated 16 August, presumably because it was sketched at the Saturday evening worship service in the Church Family's big "Dwelling House" (not in the Meeting House where it would have been very bad taste for Lossing to have sketched on Sunday—nor would he have wanted to since he always regarded Sunday as a "day of rest"). The extant pencil sketches show that he worked rapidly with the aid of a *camera lucida*[19] and that he pencilled notes on his sketches to remind himself of colors and textures for the water-colors and to record other factual details for his article. There is no reason to assume that the watercolors were finished during that crowded Monday, and every reason to assume that Lossing produced them at his leisure after he had

18. What Lossing reports is a fairly accurate précis of a much longer account Evans copyrighted in 1858, *Shakers: Compendium of the Origin, History, Principles, Rules and Regulations, Government and Doctrines of the UNITED SOCIETY OF BELIEVERS IN CHRIST'S SECOND APPEARING; with Biographies of ANN LEE, William Lee, Jas. Whittaker, J. Hocknell, J. Meacham, and Lucy Wright* (New York, 1859).

19. The *camera lucida*, invented by the English chemist and physicist William Hyde Wollaston (1766–1828) played a key role in the production of sketches, illustrations, and wood-engravings in the nineteenth century. It consists of a prism fitted with an eye-piece and attendant lenses, mounted on an extendable rod that attaches to a table or a drawing board. When the user looks down through the eye-piece, he sees the scene before him projected onto the plane-surface of the paper or wood-block on the table. He can adjust the eye-piece so that he can also see his hand and thus can trace the image of the object (or the sketch or the watercolor) before him. The *camera lucida* was widely used by professional artists and amateur sketchers throughout the century.

returned home to Poughkeepsie. Lossing used watercolor for his visual instructions to wood-engravers because that method was economical. It was far less time-consuming to indicate light and shade and texture in watercolor than it would have been to detail them in a pencil sketch.

The sketches and watercolors reproduced in this volume reflect Lossing's initial training and sustained practice as a wood-engraver. Whenever possible wood-engravers worked with a *camera lucida,* virtually tracing the illustration on the block. Lossing not only used a *camera lucida* in the field to make his initial pencil sketches, he also used the *camera lucida* in translating his sketches into watercolors, just as he (or the wood-engravers at Lossing-Barritt) would use the *camera lucida* to translate a drawing or watercolor to the block (if the proportions and composition of the drawing or watercolor were appropriate to the medium of the wood-engraved illustration). The proportional reduction in size from sketches to watercolors to wood-engravings in Lossing's work reflects this process of tracing and retracing, each step focused on the printed illustration as end product.[20]

The original watercolors are quite small; and the size, the composition, perspective, line and shading combine to translate directly into the medium of wood-engraving with little loss of detail or of readability in the process. There is, of course, a loss of delicacy and transparency as a result of the difference between the two media, but the wood-engraver did not have to take liberties with the watercolors in adapting them to the limitations of the wood-block. This was not always the case in the wood-engraving industry. Artists trained and practiced in other media tended to produce sketches, watercolors or paintings that had to be recomposed by the wood-engraver (and that were often manhandled in the process). The Civil War sketches that Winslow Homer made in the field for *Harper's Illustrated Weekly* have, for example, a visual power as sketches that shades toward crudity in the wood-engravings printed in the magazine. This was not Homer's "fault," but a result of the disparity between the modes of perception appropriate to the two media. Homer's style was not uninfluenced by the requirements of sketching for wood-engraving

20. See illus. 5a and 5b and the related wood-engraving, "Interior of the Meeting House at New Lebanon." The original pencil sketch measures $8\frac{1}{2}''$ by $12\frac{1}{4}''$; reduced to $2\frac{1}{2}''$ by $6''$ in the watercolor; and further to $2''$ by $4\frac{1}{2}''$ in the wood-engraving. Similarly, illus. 10a and 10b, "Interior of the Laboratory": the pencil sketch is $6\frac{1}{4}''$ by $9''$; the watercolor, $4''$ by $5\frac{1}{2}''$; the wood-engraving, $3''$ by $4\frac{1}{2}''$. Illus. 14a and 14b, "The Finishing Room," show a similar reduction, accommodating the scale and proportion of the watercolor to that of the wood-engraving, from the pencil sketch, $6\frac{1}{2}''$ by $10\frac{1}{2}''$, to the watercolor, $4\frac{1}{4}''$ by $6\frac{1}{4}''$, to the wood-engraving, $3\frac{1}{2}''$ by $4\frac{1}{2}''$.

(the need for hard edges and strong highlights), but he did not conform to those requirements nor regard them as primary the way Lossing did. To record and illustrate was secondary from Homer's point of view, primary from Lossing's point of view. Clearly, Lossing was the lesser artist, but his eye was informed by the preoccupations of the journalist-historian. As he prepared the watercolors, Lossing would also have been outlining locations for the illustrations in the article-to-be and determining sizes commensurate with the importance of the illustrations in context. Lossing's final draft of "The Shakers" (now in the Huntington Library in California) includes marginal notes and overlays that dictate the sizes and locations of the illustrations in the printed article.

The illustrations suggest that Lossing was treated as something of an exception by the Shaker community during his visit. The Shakers were generous and hospitable in practice, but also inclined to be reserved, to shield their members from too much of the world's attention. Many Elders and Eldresses were reluctant to allow members of their Shaker families to be extensively interviewed or to sit for their portraits. Shaker attitudes toward the visual arts were somewhat mixed in any case. One attitude, set down and in all probability overstated in the 1845 revision of the *Millennial Laws*,[21] was a blanket

21. *The Millennial Laws* were promulgated in 1821, revised in 1845 and again in 1860 and 1887. From their inception, the *Laws* stood in a somewhat ambiguous relation to Shaker life. They were initially compiled in answer to a widely felt need among the Believers by Brother Freegift Wells of the Watervliet (Niskayuna) community in 1820–21. He showed the manuscript to Mother Lucy Wright (1760–1821), the last survivor of the original founding Fathers/Mothers (the so-called Parent Ministry, the original Lead Ministry). "Surprisingly, Mother Lucy refused Wells's request [that the *Laws* be published]. She was afraid that the act of recording Shaker rules would limit the freedom of successive leaders to change them as a result of divine revelation" (Brewer, p. 40). But shortly after Mother Lucy's death in 1821 the need for codification and uniformity of discipline overrode Mother Lucy's wishes and the *Laws* were published anyway. The result was a fluctuating polar opposition between literalists (or conservatives) who wanted the codes of Shaker behavior clearly spelled out and enforced and progressives (or liberals) who argued in favor of continuing revelation in the Millennial Church's progress toward "purity." Many of the strong prohibitions of the *Laws* may well have been aimed at everyday practices that had gotten out of hand or were threatening to get out of hand (much in the same way that many of the Blue Laws of seventeenth-century New England seem to have been promulgated after the fact of the misbehavior they sought to proscribe). Thus, *The Millennial Laws* cannot be uncritically accepted as an accurate reflection of everyday life in a Shaker community.

prohibition: "No maps, Charts, and no pictures or paintings, shall ever be hung up in your dwelling-rooms, shops, or Office. And no pictures set in frames, with glass before them shall ever be among you."[22] On the other hand, there is the contradictory witness of the "gift drawings" of the 1840s and 1850s and the rich tradition of the Shaker map-making enterprise.[23] The Shakers did preach a spare and simple (though by no means colorless and undecorated) functionalism. Their emphasis was on community craftsmanship rather than on individual styling, and their accomplishments in tools, furniture, and architecture were studied and often inventive adaptations and simplifications of traditional forms.[24] In some conservative communities the Elders flatly forbad the making of pictures or portraits. This was obviously not the case at New Lebanon in 1856. Lossing made four identifiable portraits (see illus. 10a, 14a, and 18) which are evidence of the new openness to the world that was stirring the New Lebanon Community in the 1850s. But it is worth noting that with the advent of photography Shaker inhibitions about the taking of personal likenesses seem effectively to have disappeared.

Lossing's "first," his publication of the first full set of eye-witness illustrations of the Shakers, may not strike us as unusual in this age of photographic documentation, but in his own time it was unusual, a function of his unique way of working as chronicler-illustrator. Without a camera, he was among the first photojournalists, but with an irony: His black-and-white wood-engravings encouraged an abiding image of the Shakers as a good gray people, an image pleasantly subverted by the watercolor phase of his illustrating process which clearly documents a perhaps sober people but a people with color in their lives.

A Note on the Text: Some Confusions Resolved

In the 1930s two scholarly articles combined to attribute Lossing's article, "The Shakers," to Walt Whitman. The confusion arose when a hitherto unknown notebook account of a visit to the Shakers at New Lebanon was dis-

22. Quoted in Edward D. Andrews, *The People Called Shakers* (New York, 1953) p. 272.

23. See David W. Patterson, *Gift Drawing and Gift Song: A Study of Two Forms of Shaker Inspiration* (Sabbathday Lake, Maine, 1983); and Robert Emlen, *Shaker Village Views* (Hanover, New Hampshire, 1987).

24. See June Sprigg, *Shaker Design* (New York, Whitney Museum of Art, 1986); and June Sprigg and David Larkin, *Shaker: Life, Work, and Art* (New York, 1987).

covered by Professor Emory Holloway in a sizeable collection of Whitman materials then in the possession of W. T. Howe.[25] The attribution of the notebook to Whitman was understandable since most of the Whitman materials in the Howe collection had come from the collection of Whitman's friend and biographer Horace Traubel. The handwriting was not noticeably different from Whitman's, and the notebook could be made to "fit in" with Whitman's career as a journalist. Subsequently Charles I. Glicksberg collated the "Whitman Notebook" with the "Lossing article" in *Harper's* and demonstrated the two to be from the same hand, that is (he assumed), Whitman's.[26] And there, except for silence and an unpublished article by George J. Finney which demonstrates the notebook and article to have been Lossing's,[27] the matter has been allowed to rest, in large part because scholarly interest in Whitman's activities far outweighs interest in Lossing's.

Finney's demonstration of Lossing's authorship of the notebook and of the article in *Harper's* involves several interrelated investigations. He argues that Glicksberg was right, that the article and the notebook were from the same hand but that the hand was Lossing's, not Whitman's. To support this argument he traces the course of the notebook's travels back to its starting point:

> The notebook first left the custody of Lossing's family when the Anderson Auction Company disposed of "the library of the late Benson J. Lossing," in a series of eight sales during 1912–1914. The catalogue listed it under Lossing's name, describing it as:
>
>> A MS. Notebook containing the journal of a trip to the Lebanon Shaker settlement, with a description of the services, some account of the extent and condition of the colony, several pencil sketches showing the costumes of the Shaker women. Evidently the basis of a magazine article. 16mo, wrappers. n.d.[28]

25. Emory Holloway, "Walt Whitman's Visit to the Shakers," *The Colophon*, Part XIII (February, 1933). The article presents the text of the notebook with editorial comments.

26. Charles I. Glicksberg, "A Whitman Discovery," *The Colophon, New Series*, I (October, 1955) pp. 227–33.

27. George J. Finney, "A Visit to the Shakers: Lossing not Whitman" (December, 1940). I am grateful to Mr. Finney for permission to use his unpublished article as the basis for much of the discussion that follows.

28. Anderson Auction Company, *Americana, the Library of the Late Benson J. Lossing. Part II, Books and Letters—L to Z.* June 5–6, 1912, p. 142, item 1329 (Finney's note).

Finney continues:

James P. Drake, Inc. bought it and sold it the same year to William B. Gable of Altoona, Pennsylvania. Then, apparently the notebook was laid away and forgotten. It did not appear in any of the eight major sales of Gable's literary property held in 1923–25.

Not until 1932 was it offered for sale again. By that time it had lost its identity enough to be listed by the cataloger:

> WHITMAN (WALT). AN ENTERTAINING NOTE BOOK OF THE GREAT POET, KEPT DURING THE WAR. It comprises 36 pages, 16mo; written in Pencil and interspersed with DRAWINGS.
> This interesting little book was probably kept to record his observations while on a lecture tour. It contains an UNPUBLISHED HUMOROUS POEM of 30 lines: an answer to an amorous swain who had sent him some doggerel. There is also a little verse about fools who write their names in public places.[29]

From this misleading description [Finney continues] it would be difficult to recognize the notebook either as that sold in 1912 as a Lossing item, or as that subsequently published by Holloway as Whitman's work, were not two adjoining pages of the manuscript reproduced in the catalog. One of these pages was reproduced also in Holloway's illustration. . . . As for the basic error, previous sales had revealed the large quantities of Whitman material Gable had collected. He had been intimate with Horace Traubel who had supplied Gable with a large share of his Whitman relics. If the records of Gable's purchases were not available when his property was auctioned, the similarity of the handwriting in the Shaker notebook to Whitman's hand may have led to the natural deduction that the notebook had been passed on to Gable by Traubel. Those who knew the Gable collection best seem to have accepted the theory that the Shaker notebook had once belonged to Traubel. Holloway, however, gave no evidence to support this surmise, nor has the present writer been able to uncover any.

The late Mr. W. T. H. Howe obtained the notebook from the Gable sale,[30] and for eight years it remained in his possession. The entire Howe collection was purchased recently by Dr. Albert A. Berg. In September

29. Samuel T. Freeman & Co., *The William B. Gable Collection, Part I. Valuable Autographs and Rare Books . . . May 3rd (1932)*, p. 75, item 470 (Finney's note).
30. Holloway, op. cit. (Finney's note).

1940, Dr. Berg presented it to the New York Public Library, where the notebook now rests in a room specially prepared for the collection.[31]

Finney sought the help of Lossing's daughter, Mrs. Helen Lossing Johnson:

> She produced Lossing's own copy of Volume XV of *Harper's* in which he had entered his name in the index opposite the anonymous listing of *The Shakers*. . . Some months later, among her father's papers, Mrs. Johnson came across a manuscript, written and dated by Lossing, which was unmistakably a preliminary draft of *The Shakers*.[32]

Finney makes extended comparisons of passages from the notebook with passages from the January 1857 draft and from the final article, demonstrating that article, draft, and notebook were three phases of the same individual's process. The final manuscript draft of the article, now in the Huntington Library,[33] was not available to Finney in 1940, but the provenience of that draft as Lossing's is indisputable, and it represents a final link in this constellation of evidence, since it is the article as printed except for the addition of three sentences (see Lossing article n83). The manuscript also includes the attached overlays in which Lossing indicated the positioning of the illustrations that he had prepared for the article.

One further piece of evidence was not available to Finney, one that places both Lossing and the notebook at New Lebanon in August 1856. Lossing wrote in his notebook, "Send magazine containing article to Daniel Searing [sic], Union Village, Ohio, Lebanon, P.O." While he was visiting the New Lebanon community, Brother Daniel Sering was being guided and entertained by Isaac Newton Youngs whose manuscript journal is preserved at the Western Reserve Historical Society. Youngs noted in a journal entry under August 1856 that he had spent the day at New Lebanon with Sering and "Benson Lossing, who was making drawings of our buildings"; that is, in the course of the day each had noted the other's presence in his notebook/journal.

Finney's article, substantiated by the fact that *Harper's* in its General Index

31. Finney, op. cit., pp. 17–19.

32. Ibid., p. 8. This Lossing manuscript is now in the New York Public Library. It is dated, "Poughkeepsie, January 23, 1857" on the title page.

33. The Huntington Library lists it under LOSSING, Benson John, 1857, "The Shakers," LS 14 (1), 33 pages of Lossing text "The Shakers."

(1852–92) confidently lists "The Shakers" among the 57 articles Lossing contributed to the magazine in the course of his life (p. 415), by Lossing's final manuscript now in the Huntington Library, and by Youngs' manuscript journal, provides conclusive external evidence of Lossing's authorship.

There is internal evidence as well, including Lossing's remark "I have endeavored, in this brief sketch, to give a faithful outline-picture of the Shakers, with such drawings of objects of interest as I was able to make during a sojourn of two days with them."

There is also the matter of style, perspective, and content. Lossing's style is the "common style" of the mid-nineteenth century journalist-historian, and his perspective is that of the chronicler-patriot-philanthropist-Christian-philosopher. Both his style and his perspective contrast sharply with Whitman's "experiments in language" and with Whitman's attempts at a personal and Bardic celebration of the fullness of American life. Furthermore, Whitman never would have tacked on (as envoi) that quasi-ambiguous and sentimental stanza from Coventry Patmore's 1856 best-seller *The Angel in the House*.

The irony is that once the Lossing/Whitman confusion has been resolved in favor of Lossing, whatever controversy there was becomes a minor matter, of interest to those interested in Lossing's work but of virtually no importance to public and scholarly interest in Whitman.

Lossing's Article

Lossing's article about the Shakers is characteristic of his style, that of the charitable and interested witness who tries to record what he sees and hears. He does not probe as much as he accepts, and he does not subject what he reports to search and criticism unless the quotation from Coventry Patmore's celebration of married love, *The Angel in the House*, with which Lossing closes his article, can be taken as a tactful criticism of the Shaker practice of celibacy. But even that quotation does not imply criticism of the Shakers as much as it reflects Lossing's affirmation of views he shares with his audience, the readers of *Harper's*, for whom Patmore's book-length poem was the most appealing poetry of the season, 1856–57.

Lossing saw the Shakers much as his audience would have seen them: Their convictions were strange and eccentric, but their behavior was pious, sober, and industrious. He apparently did not look for the dark underside of Shaker life. He does not, for example, seem to have been aware of the rigid, if

benign, authoritarianism that ruled the Shaker world, even though at New Lebanon he was visiting the site of the Lead Ministry, the ultimate oligarchical authority not only of the New Lebanon community but of the seventeen other Shaker communities as well. Nor does Lossing seem to have sensed the perpetual and repressive surveillance to which the members of the community were subjected, the psychic pressure involved for the individual who faced the necessity of continuous confession in the attempt to *live* the Millennium, and the community's nagging and gossiping suspicion of the hidden, yet ever-present unregeneracy among the Believers themselves, the back-sliders hidden in the midst of Eden.

At the time of Lossing's visit the Shaker community at New Lebanon was already passing the peak of its prosperity. But while that is clear in retrospect, it could hardly have been clear at the time. The visitor, faced with the spectacle of a flourishing and disciplined agrarian communism and impressed by a bit of Shaker stage-management, would not have suspected (nor would he have been told of) the sense of crisis behind the scenes. For more than two decades the Shakers had been finding it difficult to recruit the young and to hold their recruits, and by the mid-1850s Shaker leaders were aware that the difficulty was approaching the dimensions of a crisis. The rural environment that had contributed to the success of the Shaker communities was changing rapidly, but the nature and pace of that change were not to be apparent to those immersed in it until after the Civil War.

Several factors seem to have combined in the making of the Shakers: The psychic energy that derived from the tradition of evangelical and pietistic revivals in the eighteenth and early nineteenth centuries; the relative advantage of communal enterprise over individual enterprise in self-subsistant agrarian communities; and the chronic depression in rural America that resulted from the lack of employment opportunities and the lack of social and economic mobility in the period before the 1840s.

From the time of the Great Awakening in the Connecticut River Valley (1734–c. 1739) until the 1840s, pietistic revivals were a recurrent feature of the rural world in this country. Many of the revivals were triggered by apocalyptic expectations of the coming of the Millennium, and most of them involved an excitement which seized and transformed whole communities. But the revivals tended to strike and pass with the pace and intensity of brush fires. A few, like the Great Awakening itself, lasted for periods of several years, but in most cases the religious fervor did not significantly alter a community's everyday

life. Eventually the fervor would be lost, usually in the long littleness of everyday life, sometimes in communal seizures of spiritual depression born of disappointment when the Millennium, forecast for the immediate future, failed (as it repeatedly did) to come. The Shaker movement had its real beginnings in such a failed revival in New Lebanon, New York (as Lossing remarks), but with a difference, and the difference was in the rapid evolution (1780–92) of a communal discipline and pattern of worship within which pietistic excitement could be sustained.

John Humphrey Noyes in his *History of American Socialism* (New York, 1870) sums up his review of those experiments in communism by remarking that a deep religious commitment was indispensable if the experiment was to be able to sustain itself beyond the first generation. He cited his own Oneida Community and the Shakers in evidence and compared their success with the relative failures of the Owenites, the Fourierists, Brook Farm, etc. Noyes did not observe that the converse apparently held true—that pietistic excitement was difficult if not impossible to sustain without the support of a closed and self-sufficient community. Nor did he remark on the preoccupation with sexuality that was common to the Shakers with their doctrine of celibacy and the Oneida Perfectionists with their equal and opposite doctrine of "complex marriage" and "free amativeness." Both communities, one by repression, the other by permissiveness, interlinked religious excitement and sexual energy in the context of highly disciplined social structures.[34]

In the opening decades of the nineteenth century self-sufficient individual farm families were at something of a disadvantage as compared to the well-organized agrarian commune. The upcountry farmer was cut off from urban markets as outlets for his produce and as sources of supply. He and his family had to rely on their own resources, and the tasks they faced were physically demanding and complex. In actuality they did practice a sort of loose communism, imaged in barn- and house-raisings, husking bees, quilting bees, etc., and in what was called in the Mohawk Valley "butchering around"— when a group, usually of four families, frequently relatives but not always close neighbors, set up informal cooperatives. During the winter, one family each week would butcher an animal for all four, sharing out quarters to the other

34. See Lawrence Foster, *Religion and Sexuality: Three American Communal Experiments of the Nineteenth Century* (New York, 1981); and Louis J. Kern, *An Ordered Love: Sex Roles and Sexuality in Victorian Utopias—the Shakers, the Mormons, and the Oneida Community* (Chapel Hill, North Carolina, 1981).

participating families. They exchanged the produce of different soils (onions from the river lowlands, cabbages and barley from the uplands); they pooled their labor forces in harvest season and took turns travelling to the market town. But these occasional cooperatives frequently broke down.

The communes that the Shakers established had the advantage of a relatively large yet diversified labor force. Everyone could turn to at harvest time and when it was time to put up foods for the winter; and yet everyone could be "gainfully employed" in his own speciality in what would otherwise have been slack time. Furthermore, individual resourcefulness did not have to be sacrificed to the recurrent seasonal demands for labor. The result in the Shaker communities during their heyday was an extraordinary combination of inventiveness and productivity.

The Shakers' success in making converts (1780–1830) depended in part on the ways in which their assertion that the Millennium was already here in the living present fulfilled the yearnings of communities in the throes of disappointed revival. The attraction of converts also depended on the Shakers' ability to demonstrate that a community life of order, plenty, and cleanliness could be achieved and sustained. There were other factors as well: Large families were the rule in the back country (the hands of many children made light work). The need for orphanages grew correspondingly, and the Shakers fulfilled that need. When the young of those out-sized families came of age and wanted to found families of their own, frequently their new families could not be accomodated without over-burdening their parents' small holdings. There were very few alternatives other than subsistence farming. The West was not really open before the development of the canals and railroads in the 1830s and 1840s. The slow beginnings of the industrial revolution had yet to turn the cities into labor magnets; and sea-faring, widely advertised all over the northeast as a possibility, was not very promising or rewarding for green-horns from up-country farms. This is not to say that the Shaker communities offered a safe haven for the unadventurous but that they represented a palpable and viable alternative.

In the 1840s and 1850s all these factors began to change. Revivals declined in frequency and intensity. The farmer's circumscribed relation to the economy of his immediate region began to open. The development of farm machinery began to free the farmer from dependence on a large, seasonal labor force. The West and the cities were becoming more accessible to the displaced young. It became more difficult for the Shakers to make converts and to hold

them; even the orphans and other children entrusted to their care were slipping away as they came of age.

In their turn, the Shaker communities, once so effectively withdrawn from the World's People, began to respond to the new social mobilities. Their commercial success increased their traffic with the world; and the world came to them, as at New Lebanon where the railroads and the resort hotels at Lebanon Springs advertised the Shakers as a tourist attraction. The Shakers themselves cooperated in lessening their isolation. At New Lebanon, Watervliet and several other communities the Sunday services were opened to the World's People and gradually assumed the tone of stage-managed performances. Particularly at New Lebanon, under the aggressive leadership of the Elder Frederick Evans, the Shakers began to carry their message directly to the world.

There is no reason why Lossing should have been aware of these changes in process. The perspective from which that awareness might have been available to him was much more the perspective of the 1870s and 1880s (chastened and informed by the Civil War) than of the 1850s; and there were, in addition, the strengths and weaknesses of Lossing's own perspective as eye-witness chronicler—busy collecting rather than analyzing all the relevant materials he could lay his hands on. His visit to the Shakers was only a two-day moment in a life-long enterprise of travelling and collecting, an enterprise that was to result in an impressive sequence of books and articles and in that over-stuffed studio-library in Dover Plains. It is against this larger background of his attempt at a comprehensive overview of immediate American history that Lossing's article and his illustrations of the Shakers should be seen and appreciated.